W9-BLQ-716

foundation course

cartooning

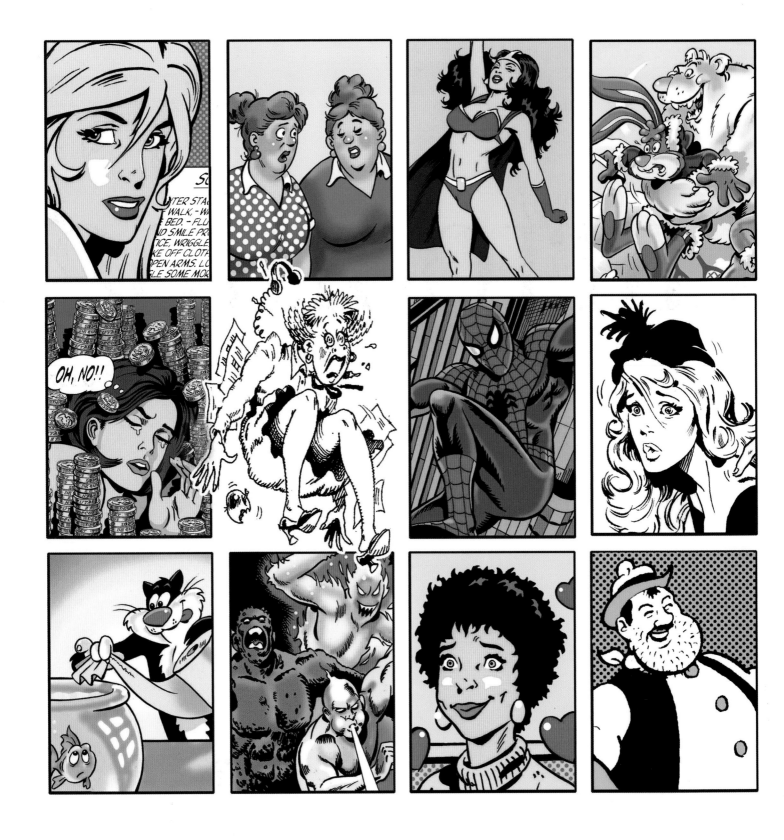

foundation course

cartooning

John Richardson

 CASSELL ILLUSTRATED

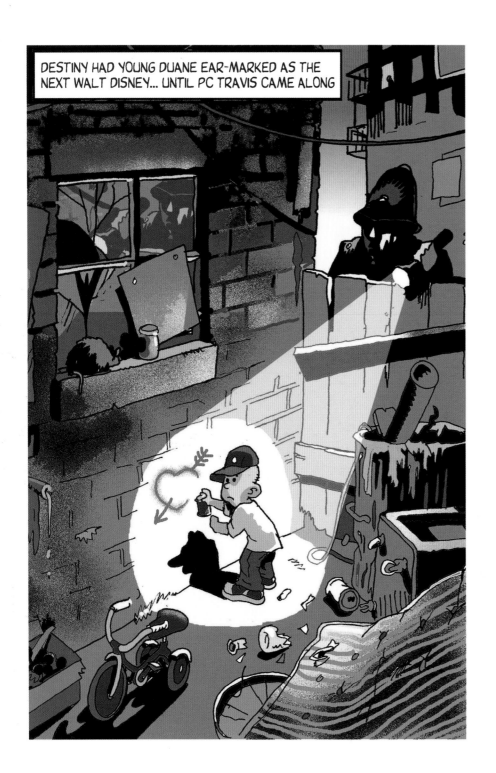

First published in Great Britain in 2006 by Cassell Illustrated
a division of Octopus Publishing Group Ltd.
2–4 Heron Quays, London E14 4JP

Text and design © 2006 Octopus Publishing Group Ltd.
Illustrations © 2006 John Richardson except those specified
on page 144.

Series development, editorial, design and layout by
Essential Works Ltd.

Distributed in the United States of America by
Sterling Publishing Co., Inc.,
387 Park Avenue South, New York, NY 10016-8810

A CIP catalogue record for this book is available from
the British Library.

ISBN-13: 978-1-844034-52-9
ISBN-10: 1-844034-52-6

10 9 8 7 6 5 4 3 2 1

Printed in China

Contents

Introduction

What is it like to have the sweetest profession in the world? Read on, and with a little luck and a bit of effort you could find out.

From the single spot cartoon, through comics and story boarding, to the highly lucrative advertising market for illustration, cartooning is a time-intensive yet enjoyable path that's fun to follow. This book attempts to guide and assist everyone who has an interest in the art of cartoon illustration. It aims to encourage the absolute beginner to get started, and then to develop, looking at the fun side of cartooning as well as the more serious side of the art, which will be of interest to both beginners and cartoonists with some experience.

The section on 'Tools and materials' provides a guide to what to make your drawings on and what to do them with – from the simple pencil to more advanced computing techniques. In 'The art of the cartoon', we consider different drawing styles and techniques as well as where to look for inspiration and acceptable source references. Once you have learned the techniques you can then look at ways of creating characters and various ways of pencilling and inking them in chapter 3.

'Telling a story' goes on to explain how to convey movement and create mood and lighting. Whether you just want to frame your work to hang on your wall, or to use today's high technology to hang it on a gigantic hoarding, sound advice is provided to help you achieve your aims.

Finally, the section on masterclasses will take you through the processes and pitfalls of several distinct areas of cartooning, including poster design, caricature and book illustration.

Cartoons are a medium flexible enough to carry any message and are limited only by their author's imagination. Cartoon images speak with a clarity that exceeds the written word, presenting as they do a pre-formed and immediate visualisation of a theme or subject. They are unlimited in subject matter as they are able to present or promote everything from love to hate, from pathos to humour, and from passion to indifference. And, while styles and techniques may have changed over time (computer-generated images are now the norm), the market for cartoons has never been better, whatever type they are – instructive, political, humorous or narrative.

Nobody does a Diplo' like our Og!

While the word 'cartoon' rolls easily off the tongue, it conjures up a variety of preconceptions in the minds of different people. The Concise Oxford Dictionary describes the cartoon as: 'a full-size drawing on stout paper intended as a base for a painting, tapestry, mosaic ... a large illustration, especially a political or satirical one, for newspaper or magazine; an amusing drawing, with or without captions, or a sequence of these to form a strip or a page; a succession of drawings that simulate a cinema film'. In addition, there's the suggestion that the word is derived from the Latin *carta* meaning card. This certainly encompasses a range of visual styles and messages, which we've come to associate with the word. But as with many art forms, the medium has developed and expanded over time.

A history of cartoons

One of the first creative things mankind ever did (after making fashion statements by wearing the skins of dead animals) was to take a charred stick from the fire and to draw.

Admittedly the drawing was on a rock wall, and the first colouring material probably led to finger-licking and subsequent death by food poisoning, but it was the first art recorded in history and its content and style might loosely allow it to fall into the category of 'cartoon'. As it was drawn on a wall it also qualifies as man's first attempts at graffiti.

Moving on from our Neanderthal forefathers – who presumably began to stand upright in order to start another frieze of cartoons higher up the cave wall – there have been others in more recent history who have found the cartoon useful. There have been the 'Septimus loves me' type of cartoon found on the charred walls of Pompeii, and 'Septimus won't pay his debts' type of cartoon drawn on the ruined walls of ancient Rome, or the 'Septimus hates Iio' sort of thing scratched on the walls of the Coliseum. It would appear that walls were the canvas of choice for

the ancient masses. Papyrus (the reed from which the first paper was made and from which the word 'paper' was derived) and parchment were still too expensive to doodle on. They hadn't yet found an efficient method of turning forests into reams of A4, but they were working on it.

Early images

Many of the earliest known cartoons, dating from the early to late middle ages, were based on caricatures of real people and were not restricted to ink on paper. Surviving buildings feature gargoyles carved from stone that portray characters whose features are found elsewhere in the same building, such as on beam and pew decorations. It is thought that they are protectors, charged with keeping evil away from the building and its occupants and they now sit like concrete cartoons, immortalised by their anonymous ancient craftsman.

By this time, cartoons had also moved into a more graphic form. Between the 7th and 13th centuries, during the age of religious manuscript production, monks and scholars were embellishing their scriptures and texts with exquisite illustrations using rich colours and gold leaf. In some instances, they also brightened up their otherwise dull existence by slipping cartoon-like caricatures into their backgrounds. These characters exhibit bald heads, beards, big ears and noses that are so at odds with the bland features used for the more conventional character illustrations of the day that they cry out 'caricature'. Again, we'll never know who they were, but the fact that they are there proves that we share something with our ancestors – a sense of pictorial humour that survives right up to the present day.

As usual, it is human nature to take something as innocent as a cartoon and to turn it into something rather unpleasant. By the early 16th century, etchings and woodcuts had become fashionable weapons in the hands of the powerful and the power-hungry. It is said that 'the pen is

mightier than the sword' and in the days of duelling and 'death before dishonour', pamphlets were often printed and circulated bearing caricatures designed to insult, ridicule and slander. Many lives ended on the blade of a sword, or received a bullet in the form of a full-stop as a direct result of a cartoonist's pen.

Political cartoons

The beauty of cartoons is their ability to transmit messages with an immediacy that words can't often match. The complicated machinations of politics and government have frequently been simplified, endorsed or derided through cartoons.

The first example of an American political cartoon is recognised as Benjamin Franklin's *Join, or die* drawing, which appeared in the *Pennsylvania Gazette* on 19 May 1754. The cartoon was very simply a severed snake divided into eight pieces. Each segment is labelled and represented a colony (see below). Franklin, an inventor and writer who owned the newspaper, wrote an article to accompany the illustration which suggested that the colonies band together against a threat from the French and the Native Americans. The division of the snake shows that the colonies were divided over the war and the caption implies that the colonies should form an alliance or be destroyed by the French and Native

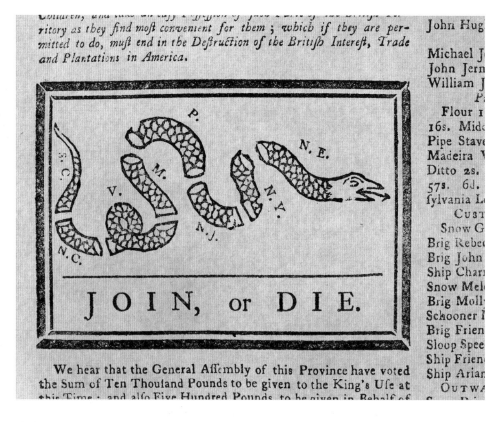

The first American political cartoon, Join, or die, *appeared in the* Pennsylvania Gazette *on 19 May 1754.*

American attackers. There are various theories as to why Franklin chose a snake. One of these is the popular belief that a snake that has been cut in half would come back to life if the pieces were joined together.

Cartoons and propaganda

In times of war, especially during the two World Wars (1914–18 and 1939–45), the cartoon as a propaganda weapon really came into its own. It served not only to drum up hatred for the enemy but to bolster the courage of the home side. The standard of drawing advanced by leaps and bounds, with the rarity of colour printing leading to some cartoonists becoming experts in the field of black-and–white presentation. Some wartime cartoon posters, where colour printing was deemed worth the expense, even ranked as works of art in their own right.

The cartoon, with its upbeat presentation, became one of the brighter aspects of those dark and dangerous days and cartoonists of the time became famous or infamous, according to which side they represented. It was discovered that Hitler, the most caricaturable of wartime leaders, had Britain's leading political cartoonists earmarked for a firing squad had he won the War. Now there's real encouragement to work harder.

Animated cartoon series such as Popeye – the longest running series ever, from 1933 and still going – reflected the war effort and Popeye's predilection for the consumption of spinach, a rich source of iron and vitamins for children during wartime, was no coincidence.

Comics, too, contained a spirit-raising, almost brainwashing, patriotism aimed at explaining the

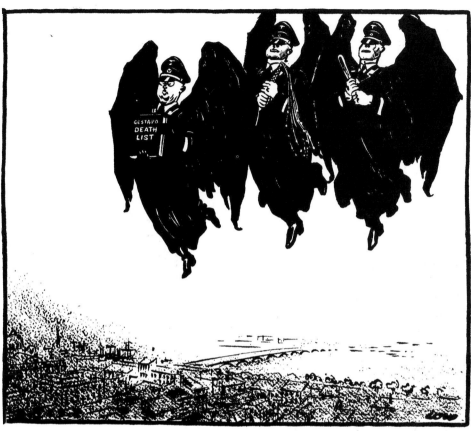

The angels of peace descend on Belgium

conflict to children of the day, who were after all the next generation of soldiers. *Comic Cuts,* established in 1890, was intended for an adult readership but began to target a younger generation at the start of World War I. By keeping its price down to a 'ha'penny' when all of its rivals were selling for twice that amount, it received a popularity boost that kept it running until its demise in 1953 – making it Britain's longest-running comic at 63 years.

Black humour also extended off the page and into battle as cartoon characters such as Donald Duck or Bugs Bunny were painted on American bombers, overseeing hell on earth being wrought below on the ground.

Golden age of comics

Following World War I, economic recovery boosted the printing industry, resulting in the publication of several new comics including the *Hotspur* in 1933, the *Dandy* in 1937, the *Beano* in 1938, and Action Comics' first *Superman* issue in 1938. A number of darker 'horror' comics, such as *Crypt of Terror* and *Vault of Horror* also became popular. The advent of such comics led to a government enquiry in the USA in 1954 and the CCA (Comics Code Authority) was formed to police and censor the industry. All American comics thereafter were obliged to accept the CCA stamp as part of their cover designs, or have their publications banned.

'What me? I never touch goldfish!'

During World War II cartoonists kept their public better informed of events through the major newspapers rather than concentrate on individual circumstance like their World War I counterparts.
(Leslie Illingworth, Daily Mail, 17 November 1939)

Horror comics were promptly banned in the USA and British authorities rushed to mimic their wartime ally by banning their publication or importation here, too.

The silver age of comics

Cartooning received a second boost in the economic revival following World War II. The period from the 1950s to the early 1970s saw an upturn in the economy and an increase in colour printing. This led to the birth of innovative comics such as Marcus Morris's *Eagle* in 1950, and IPC's *2000 AD* in 1977.

With the establishment of television, video and computer games, all of which provided alternative

(Philip Zec, Daily Mirror, 8 May 1945)
Zec's poignant cartoon sums up the sentiment felt at the end of World War II. An injured soldier, symbolising Britain, offers victory and peace in Europe – at a high cost and warns the country not to go to war again.

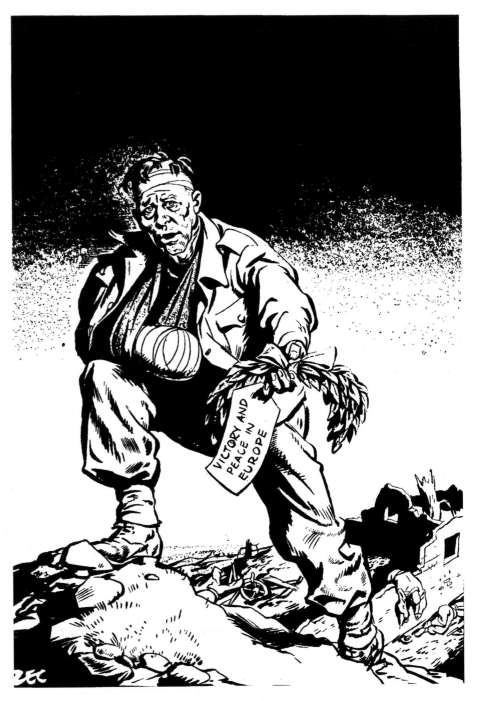

'Here you are! Don't lose it again!'

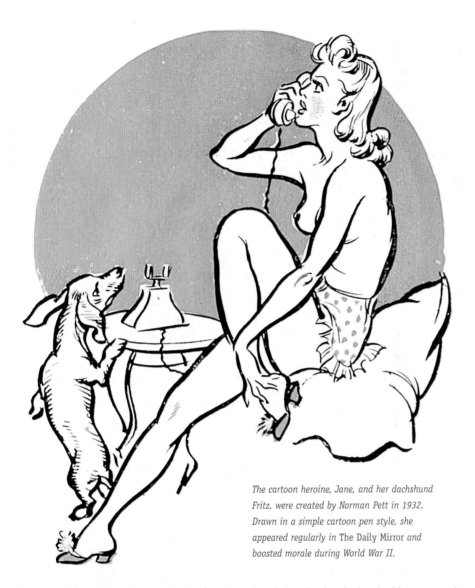

The cartoon heroine, Jane, and her dachshund Fritz, were created by Norman Pett in 1932. Drawn in a simple cartoon pen style, she appeared regularly in The Daily Mirror *and boosted morale during World War II.*

War II, strip cartoons such as *Jane* and *Garth* provided light relief from the rest of the paper's content and went on to be peacetime favourites.

After the War, when papers were no longer restricted by the 'all pull together' wartime effort, their political identities and allegiances become more marked and cartoons reflected this. Established cartoonists, such as Giles and David Low, became household names, while new artists, such as Reg Smythe who drew the *Andy Capp* strip in the *Daily Mirror* newspaper and later went on to become one of the most widely syndicated British cartoonists, were introduced.

The recovery of commercial art and business after World War II brought vast opportunities for artists, including many cartoonists. After the War, newspapers reflected the celebratory mood of the public – as newsprint paper became more readily available newspapers increased their number of pages and reinforced their identity by introducing 'fun' or 'cartoon' pages, thus offering space for budding cartoonists. Advertisements for the growing number of new products, television and packaging all provided outlets for new talent. Changes in technology also revolutionised both the production of certain types of cartoon and the definition of cartooning. Spot cartoons – single frame pictorial gags – printed larger than today, became the bread and butter of many cartoonists.

The cartoon today

The arrival of the inexpensive computer chip and massive hard-drive memory that allows scanning, sizing, colouring, toning and presentation, marked the beginning of the future of cartooning. Today we can choose whether to make use of all these facilities or whether to rely on traditional methods of hand-tinting, colouring and drawing. Either way, the essence of the cartoon remains the same – it requires artistic input, it can be used to amuse, as a visual tool, and for any number of political, educational or social ends. Whatever the end, the picture is still 'worth a thousand words'.

entertainment for children, the popularity of comics began to decline. Where once a child would practise his or her reading skills in the reflected glow of a comic, there are now too many other options to choose from. Yet cartoons have survived in plenty of other incarnations, from newspapers to advertising, and continue to be an enduring illustrative art.

While comics in the West have had their Golden and Silver ages, the market for manga (comics) and anime (animation) is enormous in Japan and beyond, particularly among adults. The appetite for manga is also increasing – the recent launch of an English version of *Shonen Jump* manga in the USA has been hugely successful.

Newspaper cartoons

Newspapers have always used cartoons as a means of defining their identity. During World

Tools and materials

Pencils and pens

To begin drawing a cartoon all you need is a pencil or pen and paper to draw on. Pencils and pens provide the cartoonist with an unlimited resource of line, colour and texture. Probably the most commonly used drawing implement, pencils are clean and portable and the variety of leads available allows a wide range of tones. Pens are equally important for cartoons and help to create fluid movement, mainly because of the liquidity of ink. There are many types available, suited to different drawing styles.

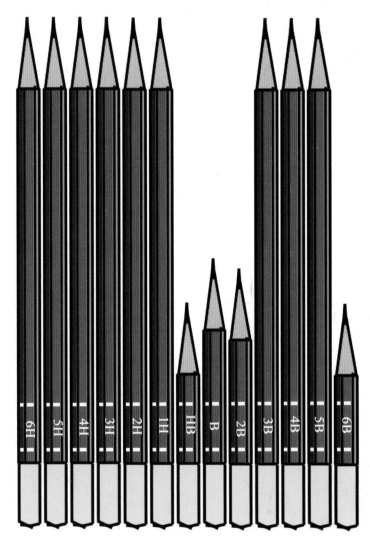

Pencils

Complete sets of 'artist's drawing pencils' presented in a beautiful tin or box are undoubtedly attractive to anyone with an artistic leaning, but given that most of these sets run from a very soft 6B to a flint-like 6H there's a good chance that half of them just will not be used. If you like using wooden pencils, it is much better to choose a reputable manufacturer and buy a dozen pencils of the type you actually need. For pre-ink roughs an HB lead is ideal as it is soft enough to erase easily after inking and not hard enough to score or damage the paper during the pencilling stage. However, if you intend to trace your first pencils directly in ink by using a lightbox under your roughs, then erasing becomes irrelevant and any lead that suits your pencilling style will do.

The majority of illustrators prefer a mechanical or propelling pencil, the type that carries a built-in supply of leads and a handy touch-up eraser in its barrel. The variety of diameters and grades of leads for these pencils is extensive and it is arguable that the ergonomic design of the barrel grip is superior to that of the pencil. If only they could imbue plastic with that wonderful cedar wood smell.

Traditional wooden pencils are available with a wide range of leads from a very soft 6B to a flint-like 6H.

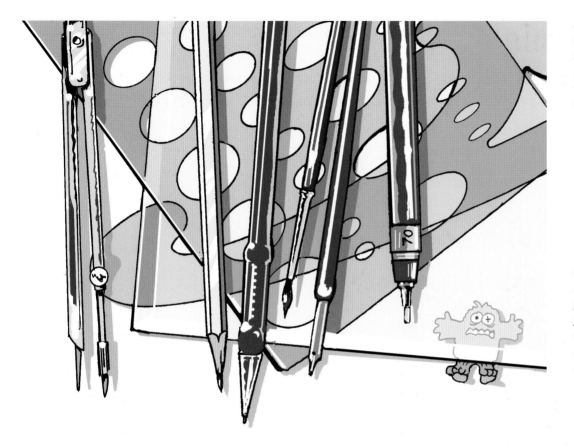

TIP

Soak new split nibs in vinegar before first use. This cleanses them of grease and prevents the ink from globulising on the nib.

Of all the available drawing tools, the least useful are the felt-tip and ball-point pen. The first uses liquid fumes for ink and has a tendency to bleed, the latter has ink that never completely dries, that is unless you leave the top off the pen.

Pens

Technical pens with tubular nibs are generally used for cartooning. These are designed to give a continuous line of fixed width regardless of pressure. This is known as a 'wire-line'. You may prefer the 'wire-line' of a technical pen or the variable line of a flexible nib, but in either case you will need to take into consideration the weight and surface texture of your paper. A very fine 303 or mapping pen nib will require a very smooth surface and will not work well on rougher surfaces such as poor-quality layout and cartridge paper (unless 'scratch and splatter' is an intentional part of your technique). Technical pens have a fine steel tip instead of a split nib and care must

be taken to keep the tip covered when not in use. Despite the ingenuity of the built-in 'wire and ball' clearing mechanism the tip will dry and clog up in a very short time if left uncapped. On the positive side their construction means that they can be treated a little more robustly, but what you gain in toughness you lose in line variability. As with small brushes, it isn't advisable to fill in any but the smallest of solid black areas with a technical pen: if it doesn't clog the nib then the nib will tear up the wet surface of any but the best quality papers. Use a cheap brush to fill in solid black drawing ink areas.

Technical drawing pens are made in the same size/ratio as standard cut papers – 2mm, 1.4mm, 1mm, 70mm, 50mm, and so on, which means

that if you've drawn on an A3 sheet of paper with a 70mm pen and then reduced the drawing to the next size down, which is A4, you can add to or continue the drawing with the next pen size down, that is, 50mm, and achieve the same thickness of line.

Calligraphy, or the noble art of handwriting, calls for yet another type of pen nib. The point of this nib is cut at a flat angle to facilitate a slanted line. Unless you are writing in the 'copperplate' style, which involves the use of a fine but very springy conventional steel nib, you will need a cross-cut or italic nib to give a beautifully balanced variation in line width. Separate italic nibs are available for right- and left-handed users.

Brushes and inks

There is a huge variety of brushes and inks available today. If you are creating your cartoons by hand, without the help of a computer, you will need a number of brushes for inking and to add colour. The quality of your work will depend greatly upon the quality of the brushes and inks that you use. The finer the brush, the more need for quality.

TIP

Add a drop of glycerine to the rinsing water to help keep your brushes in good condition and to assist the even flow of flat washes watercolour.

Brushes

There are some very good man-made fibre brushes on the market but the best brushes are tipped with sable hair. However, if you use india ink or any waterproof ink containing gum you will have to protect your brushes by frequent washing and drying. A No. 1 sable is a good size for inking, while a No. 0 or even a No. 00 can be used if fine detail is required. Use a less expensive and larger sized brush, or better still a computer, to fill any solid black areas. A brush tends to give a greater variety of width to a line, as it is flexible and holds a volume of ink in its belly. For this reason it requires a more sensitive touch to control it. Brushes also require some care and attention to maintain them in good order. Some artists 'clothes peg' their best brushes to the side of the water jar and leave them to soak when not in use. I prefer to wash my sable brushes in warm soapy water and then dry them off on tissue paper after use.

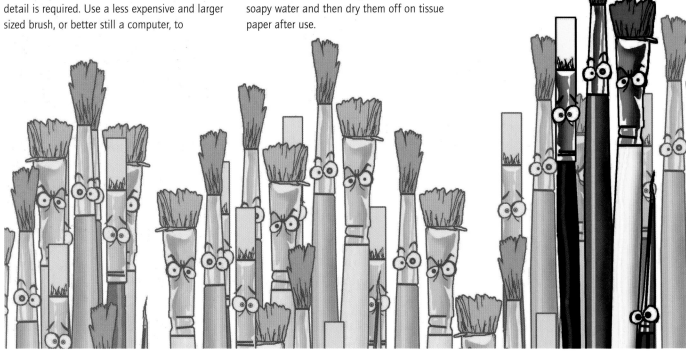

Inks

Black drawing inks are notorious destroyers of brushes and pens but we need the depth of black they provide so we're stuck with them. They often perform better when diluted with a drop of distilled water (melted ice cubes), although take care not to overdo it. Trial and error rules here.

Inks are as varied in content as they are in colour. Some are high in resin or gum content and usually dry to a waterproof finish (recommended for the black line of originals that are to be coloured at a later stage).

If you want to colour black-line original art my advice is to use water-based colours or the type of water-soluble dyes that are recommended for use in airbrushes. The colours are so brilliant and clear, and in addition highlights can be lifted off from applied colour by using just a damp brush. The dyes are of such strength that a single drop can be diluted to cover a relatively large area. Care should be taken as the dyes, even the water-based ones, will stain clothes and skin.

TIP

Don't wash your palette after using water-based dyes. Dried out dyes can be revived to former brilliance even weeks later by adding a drop or two of clean water.

For ease of use, try decanting ink from large to smaller bottles. I have a favourite ink bottle with a nice big neck for dipping into, which I continually top up from other bottles that I keep in stock. This can also be a more economical way of buying ink. Sometimes there's less spillage when you transfer ink from bottles with pipette tops, at other times it just requires a steady hand. However, when using ink always keep a kitchen roll nearby in case of spillages.

Paper and useful tools

Experimenting with cartoons can be both enlightening and rewarding, and there is no better place to start than with the basic requirement, paper. It comes in many sorts and sizes, from a super-smooth surface for brush and pen to brown Kraft paper for wrapping your artwork in. The main consideration regarding which paper to use is the way it reacts to your particular style. Try a variety of papers to find one that suits you.

The alley cat was drawn at about A4 size on illustration board using a No.1 Series 100 sable brush.

Paper

Layout pads are ideal for rough pencil work but if you wish to produce a well-finished original as a wall hanging or to give as a gift a more substantial stock is required.

In the international paper sizes system (A10 to A0) all of the height-to-width ratios of the cut sheet are the square root of two, so if you place two same-sized pages together along their longest edge the resulting sheet will have the same proportions. The A0 size (16 x A4) equals 1 sq m.

There is a vast array of illustration papers and boards available. Surfaces will depend on the media you use. One of the kindest surfaces for pen or brush work is quality tracing paper, which helps when you are tracing over a rough but does not scan very well. For smooth brushwork, such as in the cartoon of the alley cat (left), a smooth or 'hot press' surface is ideal. This paper usually comes mounted on a stiff card backing and is called illustration or fashion board. Illustration board is forgiving enough to allow even indian ink errors and textures to be scratched off its surface with a razor blade or scalpel. It can also be obtained as a flexible board or as a heavy paper suitable for wrapping round the drum of an industrial scanning machine.

Pens can work well on these surfaces too, although a very slight roughness or 'tooth' on the surface will suit a steel nib, as in the lion drawing (right), and helps the pre-inking pencil to achieve some bite. Technical pens do not work well on anything other than a smooth surface. It is

TIP

Don't be tempted to fill in solid blacks with your expensive sable drawing brush – they wear out fast enough without clogging them with ink. Instead leave the solids until last and use a bigger squirrel-hair brush to fill them in.

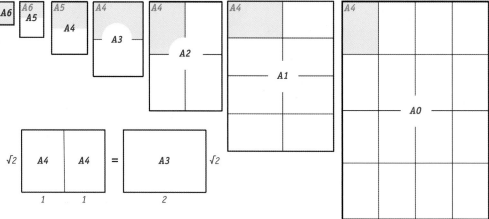

The internationally recognised paper size system.

advisable to buy a ream of inexpensive 90gsm inkjet typewriter paper for rough thumbnails and sketches rather than use quality pads.

Useful tools

For many years I hand-lettered my cartoon strips and to achieve this I used a clever machine that shifted down a line at the flick of a finger. Made by Linex and fully adjustable, it proved to be invaluable for ruling text lines and cross-hatching. However, a cylindrical rolling ruler is perfectly adequate for this job.

Also useful are French curves, and circle and ellipses templates. The curves offer so many shapes around their edges that almost any freehand pencil line can be rendered accurately by combining the curves and carefully joining the resulting lines. The ellipses template is good for text balloons and rounding frame corners in an interesting way, while the circle template eliminates the need to load and fiddle with a tiny bow compass. Another useful item is a steel or aluminium rule to use as a cutting edge for trimming artwork and mounts with a scalpel knife.

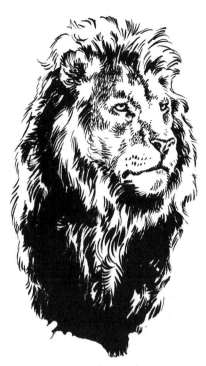

This illustration was drawn with a Gillot 303 steel nib on CS10 board and is about 220mm (8½in) high.

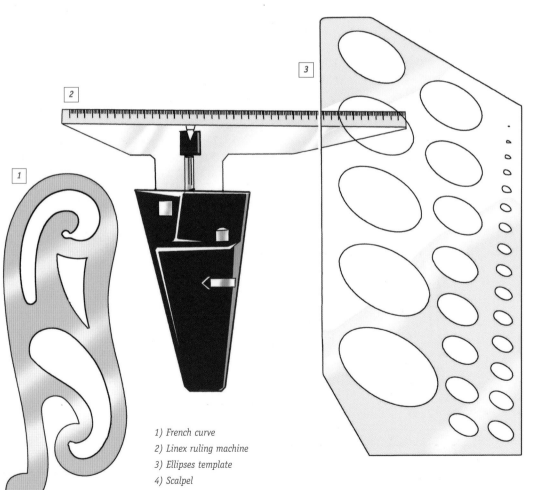

1) French curve
2) Linex ruling machine
3) Ellipses template
4) Scalpel

Computers

Computers, or at least their operating systems, become obsolete almost as fast as they can be bought so it is up to the individual to decide if the requirement is for something basic that will do simple tasks, such as colouring scanned artwork and storing it, or if the need is for a more sophisticated machine, coupled to a colour printer and scanner.

Systems

The graphics industry has been dominated for a long time by the Apple Mac computer, but advances in technology have enabled the PC to evolve through the Microsoft Windows Operating System (OS) to become a real contender. In addition, and partly due to the prevalence of digital photography, software such as Adobe Photoshop, which was originally designed for touching up press photographs, is more popular than ever and now in universal use as a design or drawing tool.

In the race for computer domination the Apple Mac is presently still leading by a nose due to its Operating System 10 (OS X) and the innovative Creative Suite (CS) which allows files to be passed between Photoshop CS and Illustrator CS. This allows Photoshop's jagged bitmapped line to be made smooth and vectored via the trace tool in Illustrator. The perfect solution to which of these programs to run would be to use both. For high-definition work in Photoshop a high dpi (dots per inch) number must be selected at the scanning-in phase to minimise bitmapped jagged edges, while in Illustrator the line is vectored or smooth regardless of any enlargement. Both programs contain more 'goodies' than most cartoonists will ever need or use and would merit a book to themselves.

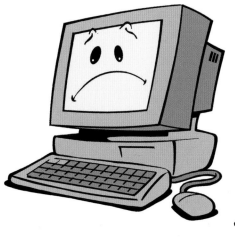
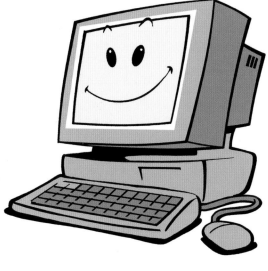

The difference between a sad and happy computer is the amount of memory available. Make back-up disks and delete unwanted material regularly.

Peripherals

There are several graphic tablets now available, sized from a diminutive A6 to a very handy A3, that allow drawings to be produced virtually on-screen using the tablet and a pressure-sensitive stylus. The stylus can be used pen-like in the fingers as a wand, pen, brush, eraser, airbrush, or anything else that was once only available through a fist full of 'mouse'. Another essential piece of kit is a scanner, without which it would be impossible to import your work into your computer (unless you had it emailed in via someone else's scanner/computer). The scanner's preferences panel allows work to be scanned direct into whatever appliance (program) you choose and is best set at a scan rate of 300 dpi, the industry average. Just as essential is a good printer in order to produce copies of your work. The most accurate of these is the Laser printer. It provides pin-sharp detail and has a large capacity, although initially the toner cartridge is expensive. Next comes the Ink Jet printer that literally blows coloured ink dots onto the paper at an alarming rate.

TIP

Beware the cheap printer that makes its manufacturer a fat profit by way of overpriced ink cartridges – the robotic inkoholic.

Hand–eye coordination can sometimes cause problems when you are using graphic tablets.

Workspace

Once your cartooning paraphernalia, which started as a pad and pencil, begins to look like ground control at Houston, with drawing boards, keyboards, screens and light boxes, printers, scanners and the rest of the essential digital wizardry, it will be time to give serious thought to some kind of secure workspace.

Another decision to be made is the size of your workspace, and if experience is anything to go by then the bigger the better. You will be amazed, if not dismayed, at how quickly you can accumulate files, reference books, and those bristles-akimbo brushes that you can't quite bring yourself to bin. Some kind of order should be established from the start, in order to function with ease. Materials and equipment should be to hand and you should

If you are unsure about making the transition from cartooning for a hobby to being self-employed, you could give it a probationary period by 'working out of a suitcase' or in a corner of a room until you develop a feel for what you need to make a proper start.

make sure that you have somewhere to store your work. If you are self-employed, invest in a few box files and ledgers for your accounts. You will need to keep accounts, however small your beginnings. It is also important to reserve some shelf space for magazines, catalogues and reference books.

If you have others sharing your computer and have reached the stage where you are dealing with actual fee-paying clients who expect confidentiality (and that means to the exclusion of other members of your household) you will need to reserve your own space on the hard drive and possibly protect it with a password. However, your first priority, if crossing the line between hobby and business, will be to invest in your own computer.

Working from home can be wonderfully rewarding if it is planned from the outset. A table will do but a desk is ideal. A corner will do but a room is much better. The family phone will do but a separate number with broadband is best. If you have the space consider even a purpose-built 'studio-shed' in the garden.

Whatever sort of workspace you make it should be well away from distractions such as television, pets and a window with a wonderful view. Also, when family and friends discover that you work from home, they will consider themselves welcome, regardless of your desperate deadlines and need for constructive solitude. But in time people will come to respect your freelance status.

Storage

Whatever your preference, spot or gag cartoons, you are going to produce a bewildering number of drawings that you could easily lose track of without a print-out of the artwork clearly marked to whom it has been sent and when. A simple clip file and hole punch is one solution that works. As well as storing files electronically it is a good idea to jot down file notes, job numbers, permits, client addresses and contacts in a hand-written ledger. You don't have to boot up a ledger and it won't crash.

Despite the terrific advancement in memory power, most modern computer memories are supporting many megabyte-munching software programs as well as the files that they create and this can at worst cause program conflicts or bugs and at best slow your machine down.

Whatever the size or your hard drive, you will need to consider portable storage for your work. Floppy disks were the original form of file transport and storage but these have been superceded in favour of Zip disks, Flash cards, CDs and DVDs both readable and writeable, and the recent key-ring USB flash drive which stores an enormous amount of data. It is like an external hard drive yet it is still small enough to unplug from your computer's Universal Serial Bus (USB) port and attach to your key ring until needed.

In addition, a high-capacity storage solution is an additional external hard drive, which will allow you to backup your files.

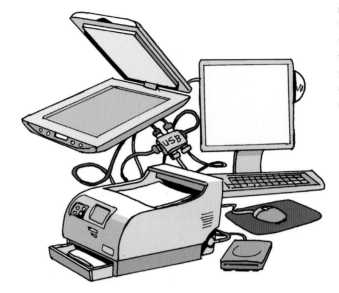

TIP

If you have your original line work, references and roughs tucked away in a drawer somewhere, don't clutter your computer's memory by storing digital copies on the hard drive.

While it is important to have a desk large enough to hold your computer equipment, shelves provide a great deal of space-saving storage for box files, books and materials.

I'm writing a filing programme for filing my files.

The art of
the cartoon

Drawing styles

There are as many styles and techniques as there are artists who practise them, but for the sake of getting started, four main types of cartoon illustration – grotesque, cute, lampoon and realistic – will be considered here.

Cute

This is not to everyone's taste but does require a degree of skill and knowledge to tug at the viewer's heartstrings.

Grotesque

In this style the gag (joke) is the essence of the drawing – its execution must be perfect to ensure success.

Lampoon

This type of cartoon relies upon the skilful exaggeration of all things physical and emotional in order to evoke humour, entertain or simply pass on a message.

Realistic

This style requires the most skill and a fair knowledge of anatomy to become adept. It also requires a fair amount of dedication to reach a professional standard.

Cartoon styles

All of the styles opposite share the need for rough preliminary sketches (except perhaps for the rare 'grotesque' style genius who can't draw an egg but can do a three-second biro sketch that has you in stitches). After the initial sketch comes the choice of technique. Dependent on that comes the choice of tools to use.

For the grotesque style the choice is usually the felt tip, technical, or ball-point pen – all of which give a simple line and are ideal for rapid, intuitive drawing and also for hatching and cross-hatching. They are, however, no use for filling in solid blacks, where a thicker felt tip or brush is needed.

The cute style requires more careful pencilling and, although the subject usually calls for a soft or brush line (see the average cute greetings card) the artist can also succeed with a pen line (as in the average cute hero in a manga cartoon).

Lampoon, because of the exaggeration involved, is more often drawn with an expressive brush stroke, although the thinner line of the pen can work too, especially in children's books, and an already exuberant pencil rough can be stretched to almost ridiculous proportions at the inking stage.

Realism can only benefit from carefully considered pencil drawings, which in turn are developed from loose thumbnail sketches. An excellent observational memory for detail at the pencilling stage helps to carry 'conviction' over into the ink drawing.

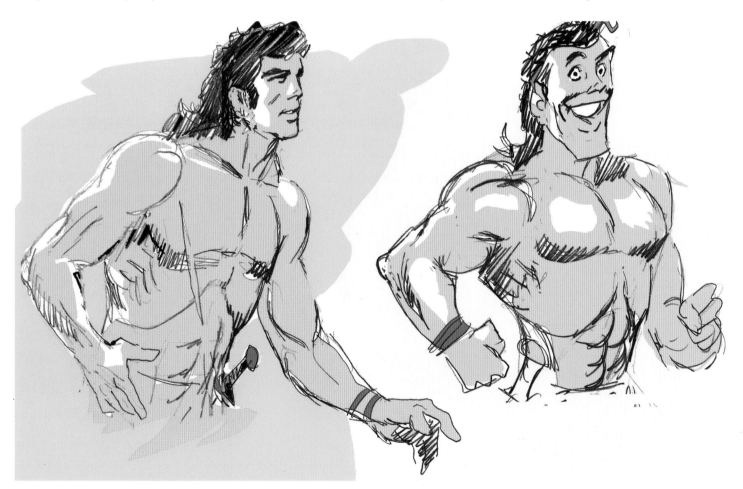

Here are two Tarzans, one sketched realistically and the other lampooned. The musculature of the arms remains the same, only a slight increase in size makes the difference.

You could copy this realistic style cartoon or scan it, print it and then add colour.

███ **EXERCISE**

Try out your drawing style

Using graph or squared paper, copy these rough pencil sketches (enlarge to a comfortable size) and use them as a base for pen or brush drawings. The four main types of cartoon illustration – cute, grotesque, lampoon and realistic – are all featured here. Refer to page 27 for advice on what tools to use, but use pencil, pen or brush as an extension of your fingers. Remember to draw with feeling and movement.

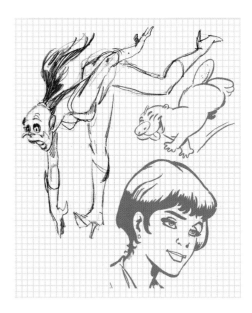

These faces and the figure would best lend themselves to brushwork.

Two more ladies needing brushing.

Brushwork for the sketched figure, but can you re-draw the other two brushed characters as pen renderings?

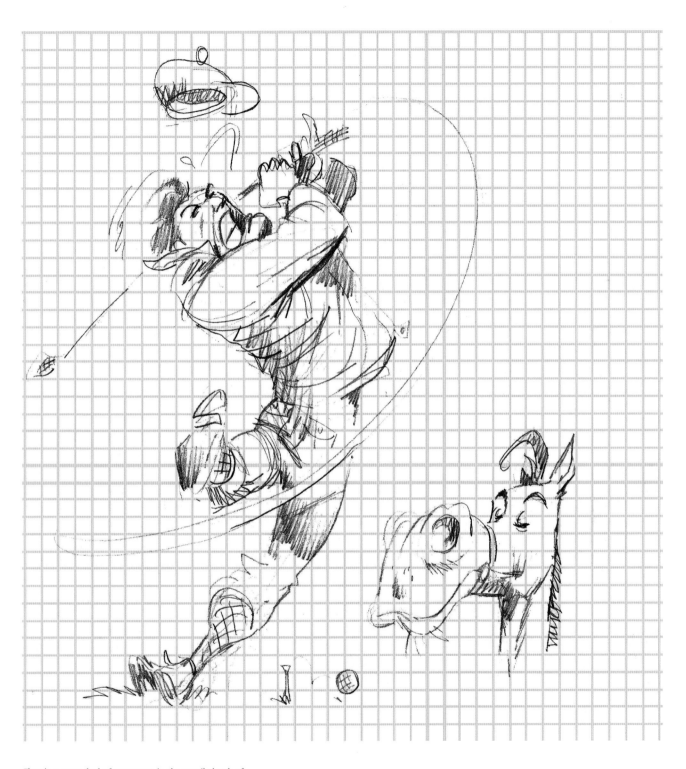

There's a great deal of movement in the pencil sketch of the Scottish golfer. Try to attain this in your version.

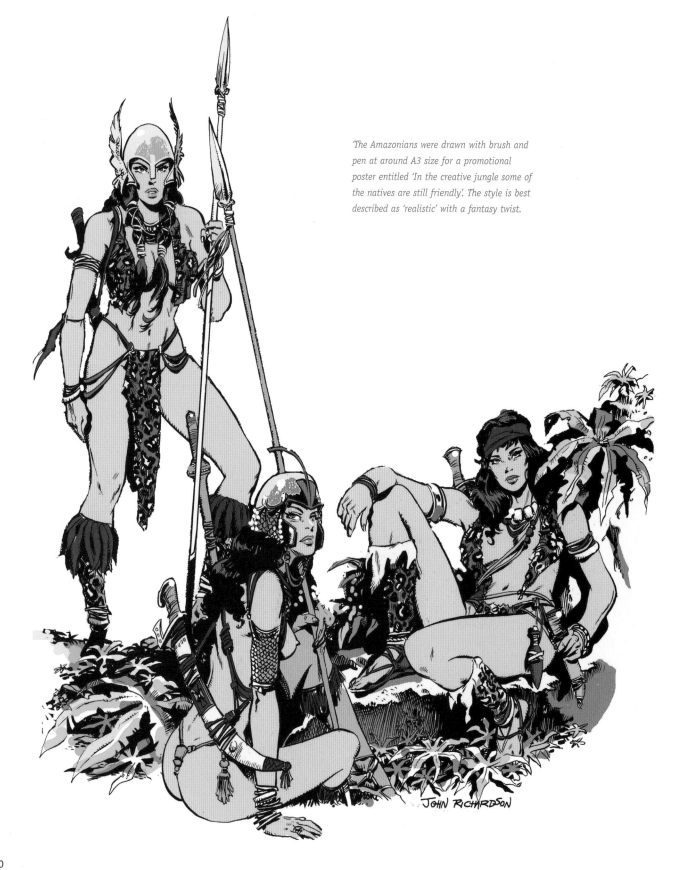

'The Amazonians were drawn with brush and pen at around A3 size for a promotional poster entitled 'In the creative jungle some of the natives are still friendly'. The style is best described as 'realistic' with a fantasy twist.

This sketch in the realistic style was drawn with a No. 1 sable brush and coloured in Photoshop. It was intended for reproduction at A4 down to 35mm.

This lively drawing was done with a 303 steel nib and a No. 1 sable brush, and was part of a sample for a newspaper comic section.

This wire-line illustration for a children's book was drawn in lampoon style to achieve a measure of excitement that comes from a free and sketchy style.

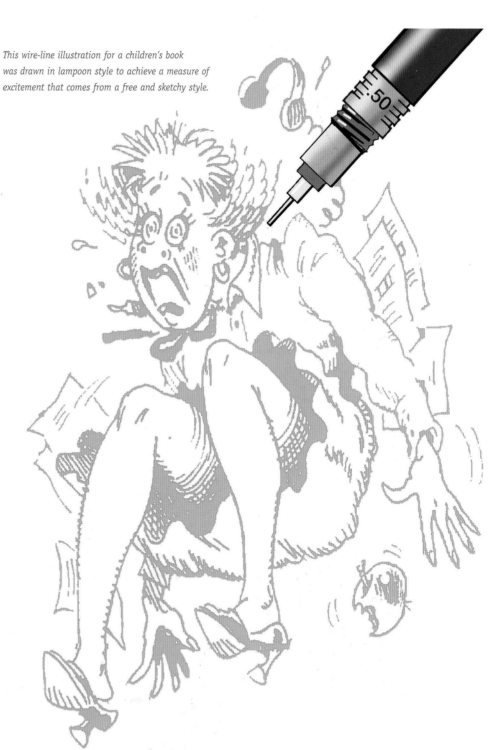

Inspiration and ideas

Sitting with a pencil and a blank sheet of paper is often enough to fire up the imagination and get the creative juices flowing. Of course, it helps to have the germ of an idea before you pick up the pencil and to consider what type of cartoon you want to draw. For instance, will it be a newspaper-type gag, a greeting card design, or a character for a comic strip? Also consider whether it will be simple, involved, or detailed.

Sometimes before you know it you're away down the creative trail, your pencil almost has a mind of its own and your eraser is beginning to smoulder. On the other hand, when you hit the dreaded 'block' you need to seek inspiration.

Potentially, you can find inspiration everywhere: it's all around you, indoors and outdoors. Familiar subjects around the home can be a starting point. Look at inanimate objects afresh and note their different shapes, colours and textures. Bear in mind the spatial relationships between them in order to create a balanced composition. Practise drawing tea cups, vases or curtains - at some point they may be the focal point of a cartoon or could just provide you with a background filler.

Pets, birds and wildlife can also provide you with inspiration. Watch them, observe how they move, take photographs of them and try to capture their character by doing some rough pencil sketches.

Outdoors there's a wealth of inspiration to be found, whether it be in the town or country, from cityscapes to seascapes, landscapes to atmospheric weather. When you go outside, sketch the objects around you and think about how you can simplify or exaggerate features and proportions for comic effect.

Sources of reference

As mentioned above, an ideal way of sourcing references is to go out and sketch or photograph your own. However, if your cartoon features, say, an elephant, then you're in trouble.

Photographs provide a good source of reference - your own and, with permission, other people's. Catalogues and magazines are particularly good as they enable you to get a general impression of what the latest fashions, bicycles, TVs and technical toys look like, as long as you don't copy or trace line for line.

Try looking at cartoons, drawings, paintings or samples of artwork done by other artists that you admire. If you are drawing for your own personal amusement there is no harm in copying from a published drawing or photograph, although strictly speaking it is illegal. But it could be tolerated just as long as your copy doesn't find its way into any form of print. This would be plagiarism and most creative people frown on the practice.

If you're trying to make up gag jokes, try asking around your friends for any recent jokes and derive something pictorial from the results. And if any of your friends have the looks or the

TIP

To photograph or caricature someone without their consent can be costly if they take umbrage and sue. Always seek permission before going ahead.

courage to model for you or your camera, there's inspiration and reference both together.

Copyright

As we spend a large amount of time gazing at our TV screens it would seem only right to gain something more from the experience than an intimate knowledge of our favourite 'soap' or 'sitcom'. However, it is not advisable to record that safari programme to 'freeze' that elephant which makes such excellent reference for your illustration and saves you from buying a book on the subject.

All published work has a copyright that is owned by somebody and plagiarism is theft. If it is obvious that a drawing has been even loosely taken from someone's photograph or artwork there can still be a case for infringement. Walt Disney Studios aren't going to sue you for painting Mickey Mouse or Donald Duck on your child's nursery wall, but if you publish the drawings, no matter how noble the cause, they would have a case.

COPYRIGHT BASICS

Copyright law is extremely complex. The following points are guidelines only; if you are in any doubt about copyright issues, always seek advice.

- The author of literary, dramatic, musical or artistic work is deemed to be the first owner of copyright and there is no need to register.
- There is no copyright in a name, title, slogan or phrase but they might be registrable as trade marks.
- A piece of work may be protected but the idea behind it is not.
- UK copyright lasts until 70 years after the death of its author.
- Adding the copyright mark to your work is not essential but may prove useful if any dispute should arise.
- If you do use the copyright mark always add your name and the date in the same line. Your agreements and invoices should all state 'Unless otherwise agreed in writing the original and all rights in this work 'NAME OF WORK' remain the property of the artist'.
- Selling as 'First British Copyright' (12 months use in the UK only, after which the copyright and right to resell [as Second British Copyright] returns to you) is generally acceptable.

Figure drawing

For the cartoonist the accuracy of anatomy required depends upon the career path followed. For instance, the creators of Homer Simpson and of Superman were both cartoonists but neither of them used correct anatomy. This section deals with average anatomy from which all cartoon figures derive their beginnings, the exaggerated anatomy of the superhero, the art of female figure drawing in comics and strips, and also some aliens.

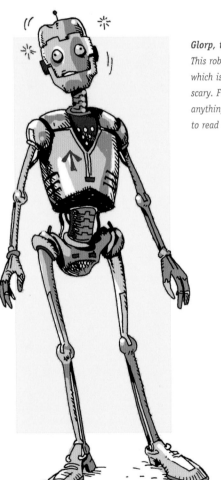

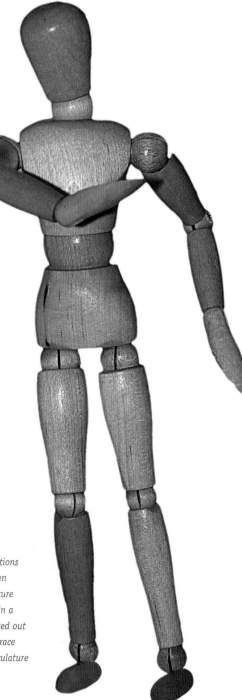

Glorp, the robot
This robot loosely resembles the human figure, which is what makes the idea of a robot scary. Fierce or friendly, the robot is never anything but fascinating both to draw and to read about.

Manikin
A good investment to help keep physical proportions in mind is the small yet perfectly flexible wooden artists' manikin, which can be used as a miniature model for on-the-spot reference, or may be set in a pose, digitally photographed into your PC, printed out at the required size and once again used as a trace sketch. Unfortunately, there is little or no musculature reference on a manikin, just an indication of hermaphroditical proportions.

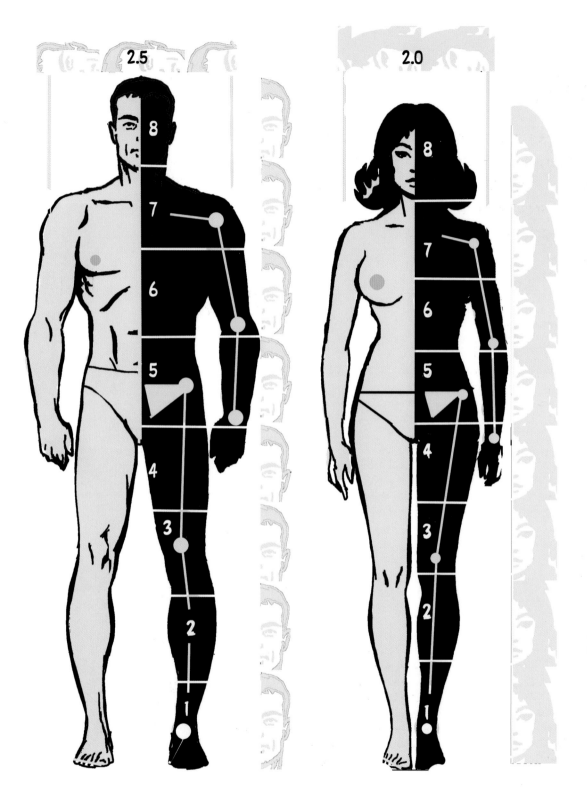

Physical proportions

The average male figure stands roughly eight heads tall. The average female figure is also roughly eight heads tall (which equates to seven male heads). If you want to draw super guys, make the figure roughly nine to nine and a half heads tall. The emphasis is on the word 'roughly' as your figures, like robots, will come in all shapes and sizes, just as they do in real life.

TIP

When drawing the hand in proximity to the face, it should measure roughly the same as from the eyebrow to the chin. Draw the male hand slightly broader and the female slightly narrower than normal.

The lightbox has a cool light source that will not damage film or plasticised paper, but prolonged use will leave you blinking.

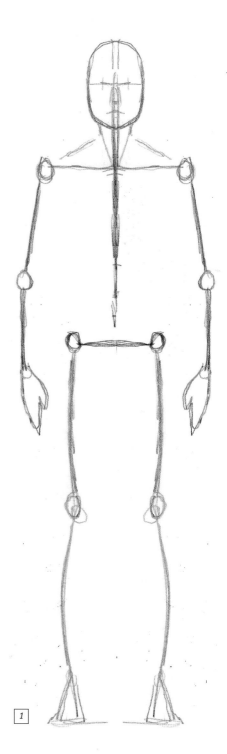

Cartoon figures

Start by drawing a matchstick figure to the proportions shown, incorporating a pelvis about twice the width of the head. The shoulders should be about two and a half heads wide (see fig. 1).

Hang an egg-shaped rib cage from the base of the neck to just above the pelvis and scoop the base out of it to accommodate the abdominal (six-pack) muscles (see fig. 2) .

Add some blobs of muscle (blobs will do as this is still a very rough sketch) on the chest and limbs, and some semblance of hands and feet (see fig. 3). If you're in a hurry try copying the illustration through some thin or tracing paper to make sure you get the right proportions. Use a pencil for this as a pen will be used to 'ink' over

the pencil rough later. Now stand back and squint at the result because this is the time to see if it looks 'right' and to use the trusty old eraser and pencil to shift those muscles into the right places and shapes. When it looks right to your eye it is time to make a drawing of it.

At this point you have several options. You can ink over your pencil sketch (see fig. 4) and erase the pencil marks later, which is common practice although it requires fairly stout paper and good ink, you can tape your rough to a lightbox, tape your paper to the rough, and ink straight onto a nice clean surface. Alternatively, you can erase your rough back to a faint line and commence to turn the rough into a finished drawing, in which case use a slightly softer leaded pencil.

TIP

If you scan the finished pencil drawing back into your computer it can look good printed out as a halftone on pastel coloured paper, especially if you then pick out the highlights in white crayon or poster paint. Have fun experimenting.

1

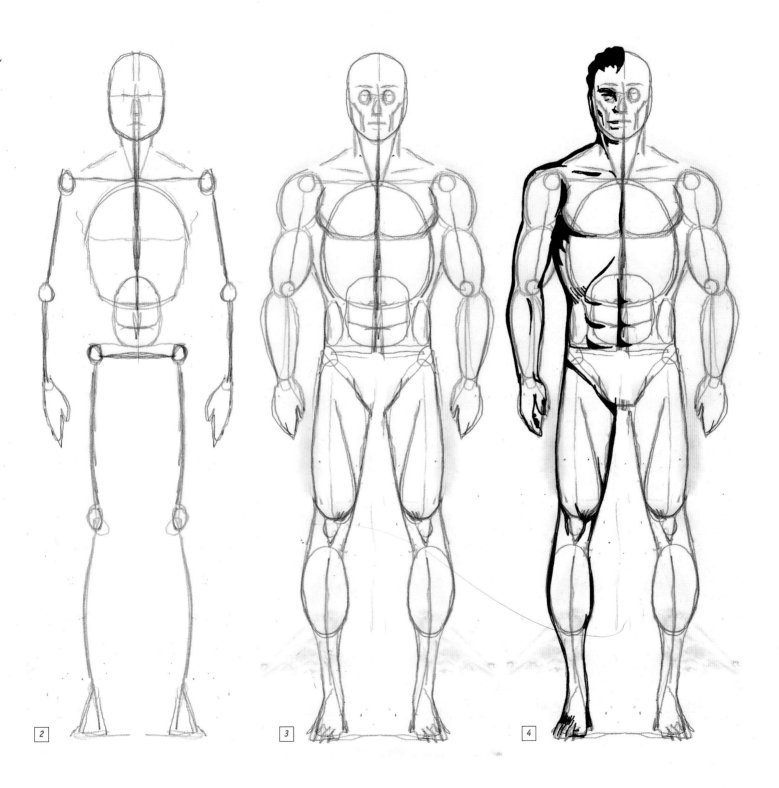

2

3

4

Superheroes

Below and right are rough pencil sketches of
two superhero figures derived from the same
'matchmen' sketches on pages 36–7 but this time
with a little perspective. Note how the head on
a well-balanced figure is directly over a point
midway between the feet. This gives a sense
of solidity to the figure. Try copying and inking
over these figures using some of the following
methods of shading: line and tone, block line,
feathered line, hatching, cross-hatching (see
opposite). Specific details on drawing hands and
feet can be found on pages 62–7.

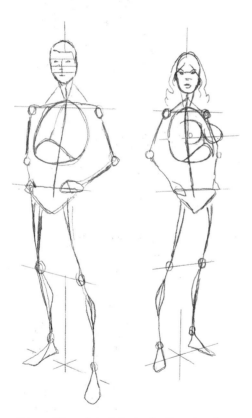

*Using an HB pencil, begin by drawing the male and
female matchstick figures. Doodles as small as this allow
general composition to be planned. Without any detail to
get in the way, a much freer layout is obtained.*

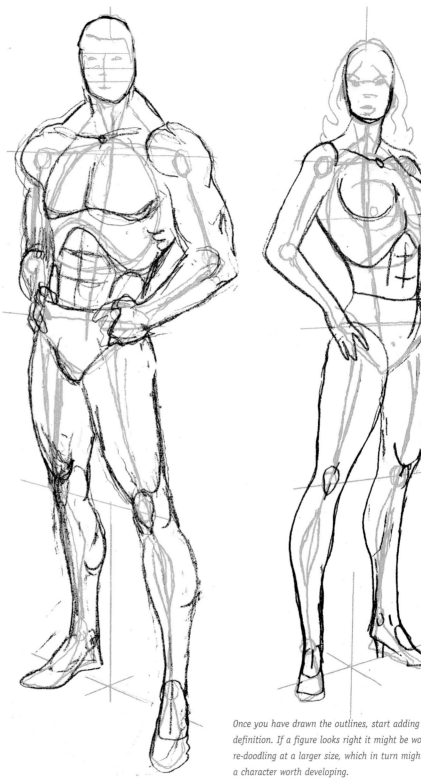

*Once you have drawn the outlines, start adding
definition. If a figure looks right it might be worth
re-doodling at a larger size, which in turn might suggest
a character worth developing.*

Line and tone

Block line

Feathered line

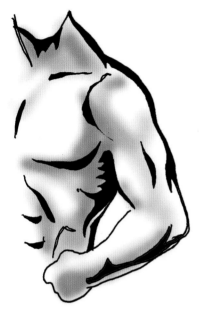

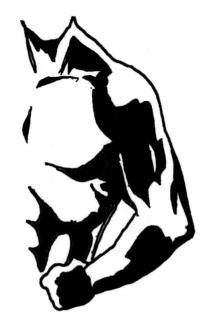

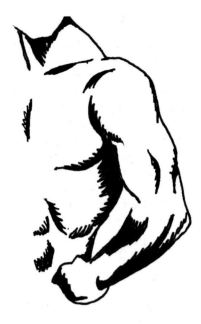

Shading techniques

Line and tone (above) adds shadows to a line work. It can be achieved with the use of pencil, watercolour, ink wash or airbrush, but be sure the line work is waterproof before commencing.

Block line (above centre) is a simple brush or pen line that either leaves the drawing open for colour or uses solid black areas of shade to contrast against white highlights.

Feathered line (above right) is usually created with a smooth brush line around an object. While the ink is still wet, the inner edge of the line is 'flicked' to give an indistinct look, suggesting that the object is three-dimensional.

Hatching (right) is a shading technique used with linear media. Solidity and form are suggested with a series of parallel lines; the denser the strokes, the darker the tone.

Cross-hatching (far right) is like hatching but the strokes are multi directional, which adds a further depth of tone.

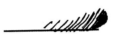

Hatching

Cross-hatching

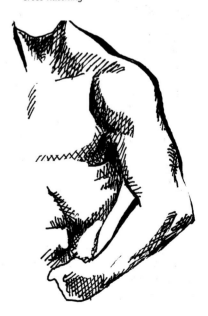

Thumbnail sketches

After coming up with the germ of an idea, doodling is the first stage of a cartoon. It can happen that while you've been musing, your creative side has covered a pristine sheet of paper with several feet of graphite and one or two of your doodles look very promising, except for a bit here and there. It's now time to exit the doodle stage and consolidate those good bits into a 'thumbnail' sketch.

Working drawings

Basically, a thumbnail sketch is simply an enlarged doodle that rectifies the awkward bits and adds some improved details until it begins to resemble the perfected image lodged in your mind. It might take two or three thumbnails before you're satisfied with the result of your efforts. It's only at this stage that you realise the difference between this and your previous random scratchings. A thumbnail is the first in a series of working drawings.

They are usually drawn at a size large enough to depict objects such as cars, figures and trees, but too small to tempt the addition of fiddly details such as textures and facial features,

unless, that is, your thumbnail is for a close-up shot. Of course, if you're really fired up about getting down to it and you've unscrambled the doodles in your head you can dispense with all this and go straight to a pencil drawing.

Pencil drawings

If you prefer the longer but safer route to finished artwork you can enlarge your thumbnails to the required drawing size either by projection, by drawing them on graph paper and 'squaring up' your drawing paper proportionally so that you can copy the thumbnail square for square, or by the best route, which is to scan them into a computer, enlarge to size and print out as a trace drawing.

Doodles as small as this allow general composition to be planned. Without unnecessary details to get in the way a much freer and more lively layout can be obtained.

When a figure looks right, try re-drawing it at a larger size and adding more detail using shading techniques (see page 39).

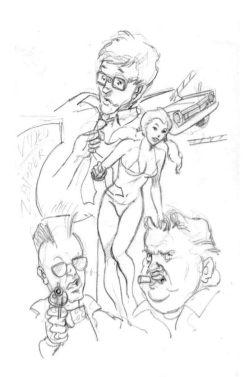

Here is a pencil rough design for a video cover that didn't reach the inking stage.

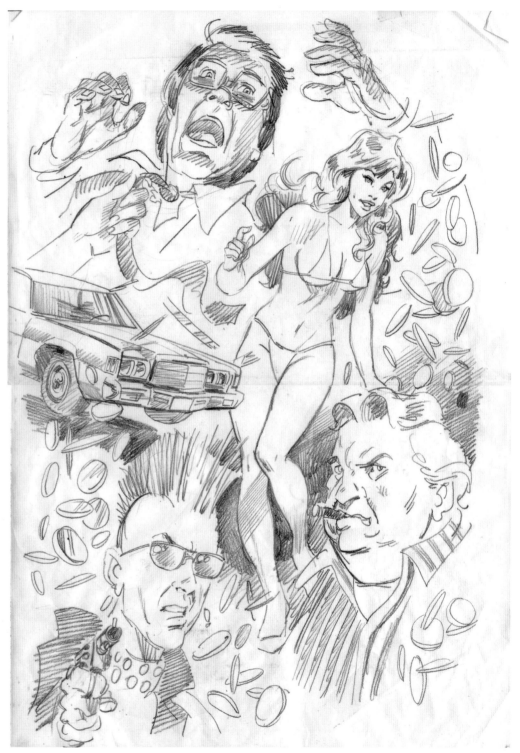

This version of the video cover sketch is very similar to the one above but the components have been rearranged to suit the client's wishes. This one didn't reach the inking stage, and as far as I know the project was dropped, which demonstrates the hit and miss nature of trying to meet a client's taste.

Adding tints

Mechanical tints, or transfer tints, come in a variety of styles, colours and applications, from simple dots to the involved and complex patterns of Art Nouveau. They can be applied to three-dimensional objects such as mock-up packaging or one-off greetings cards or generated and applied by computer. However, it should be noted that newspaper spot cartoons are usually printed so small that dotted tints generally do not register.

Once you have your black and white ink drawing you might wish to enhance it a little further by the addition of black and white mechanical tints. These come in the form of dots, stripes, stipple and various patterns, and are available from art shops and graphic equipment outlets as rubdown or adhesive sheets. Rubdowns are applied by covering the selected area with the sheet face down and literally rubbing the back of it with a smooth stylus to transfer the tone to the drawing. A more accurate result is achieved with the adhesive sheet, which is peeled from its backing and applied to the drawing, after which the excess is trimmed off with a scalpel knife and the affixed tint burnished flat. These methods are inadvisable if you intend to hand-colour the original drawing later as neither adhesive nor rubdown tints will readily accept colour on top, and they are equally reluctant to affix themselves properly on top of previously applied colour. It is best to acquire a print, or several prints in case of mistakes, to colour up after the tone has been applied, or actually apply the tone in the computer (see Lichtenstein masterclass pages 104–9) at the same time as the colour.

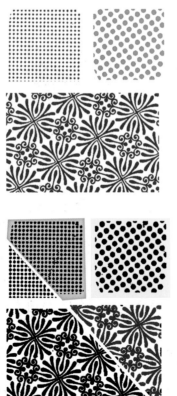

If your tint is black and white and you have the computer software, try selecting and colouring it.

This type of mechanical tint can be applied as rubdown, cut and tack, or by computer generation.

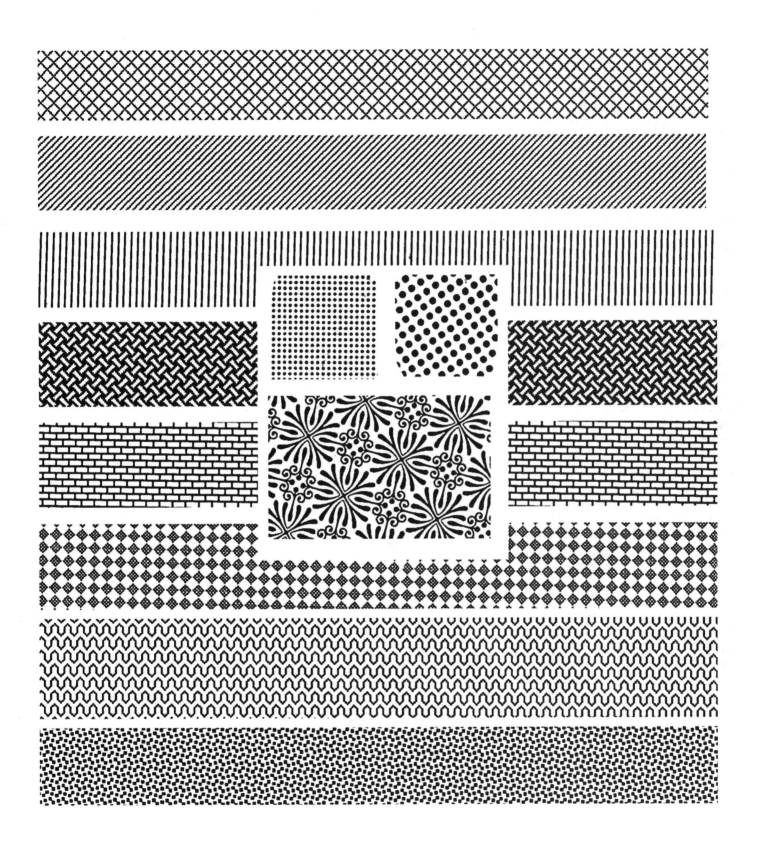

Adding colour

Whatever kind of cartoon you're working on, they all follow the same process of doodle, thumbnail, pencil, inks then colour, but what kind of colour? There are two main methods of adding colour, either by computer or by hand. If you are adding colour by hand, choose from a variety of media – ink, watercolour or coloured water-based dyes.

This book-cover illustration in lampoon style was initially pencilled at 35cm (13¾in) high to give greater detail, then inked with a good No. 01 sable brush to mimic the established style of the original characters. It was then scanned into Photoshop and coloured using a combination of paint pot, selection wand and airbrush tools.

The figures, Super CC and Super Cecilia, created for a comic strip in *Custom Car* magazine, were drawn to fit into the confined space of an established background, hence the somewhat strange leg positions, so they were placed as individual layers over the cover art and manipulated to fit the design.

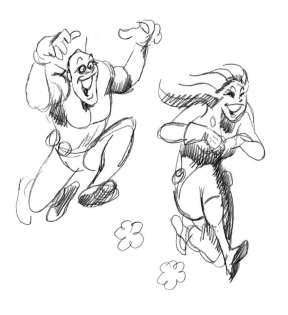

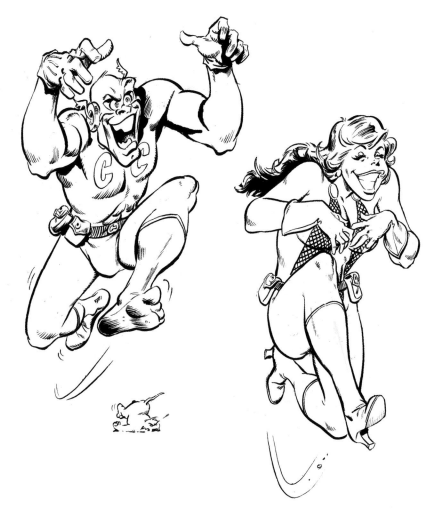

TIP

When you have a long curve to ink with a brush, let your longest finger, the one your brush rests on, act as a 'runner' on the paper in front of the brush to steady your hand.

Colour types

On computers the two main colour types are RGB (Red, Green, Blue) and CMYK (Cyan, Magenta, Yellow and Key line [Black]). RGB is used for video outlets such as internet websites which require an intense depth of colour. CMYK refers to printing ink and is used in publishing. There are hundreds of formulated Pantone colours that can be used in addition to CMYK. These can be chosen on screen and accurately matched later at the printers. You can convert RGB colours to CMYK and vice versa.

Applying real ink to paper is a personal thing and each illustrator will have their own method. However, there are fundamental practices that might benefit all. Stretching your paper over a stout board will give you a beautiful surface to paint on that will dry flat and taut. Briefly submerge the sheet in a basin or bath of water and allow the excess water to run off. Lay it on the board for five to ten minutes to let it absorb water and expand, then tear strips of gummed paper to the required lengths, run them through the water and immediately use them to fasten the paper to the board. You should end up with wet wrinkled paper, loosely plastered to a soaking wet board by wet gummed tape. Let it dry; do not hasten the drying process but give it a few hours and you will be rewarded by a drum-tight result. Be warned, that if you try to stretch paper which has been pencilled the pencil lines will be rendered faint but permanent by this process.

Watercolour is best applied as a pale tint of the chosen colour and 'built up' by additional darker washes until the required depth of tone is achieved. Coloured water-based dyes will work in the same way but adding a second darker wash tends to loosen the first layer, resulting in a different tone from that expected.

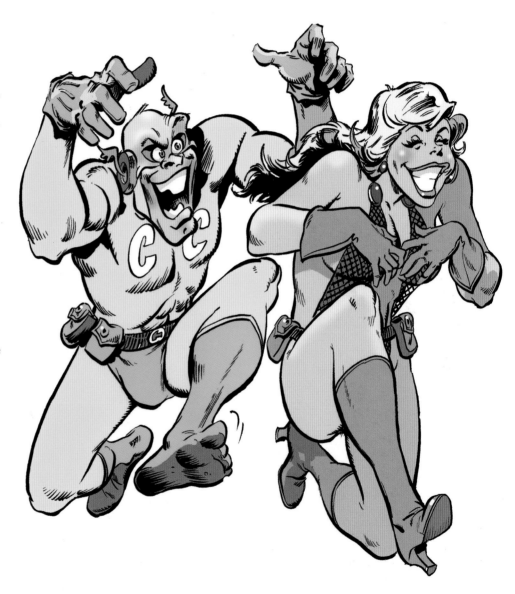

Considering your audience

In order to have a saleable product, every cartoonist needs a client, and although it is relatively easy to churn out your own work and hope for the best, it is much safer to tailor your material to suit the needs of specific clients and target them. Remember, whatever your views may be, your client's view will differ from your own in some ways and must be reflected in the work that he or she funds. Once this difference is recognised and accepted, mutual respect ensues.

This gag cartoon is ironically aimed at cartoonists.

The audience for your cartoons must always be a major consideration – whether for adults or for children.

There are as many morals as there are men.

If you are drawing for your own amusement or that of close friends then you will know your audience, but if you are working for others, especially if you are receiving a fee, then you must adhere to the moral standards laid down by your client and if there's any doubt about this on either side it should be resolved at the outset. A newspaper, renowned for its nudity content, might commission a cartoon strip with the intention of syndicating it world wide at a later date, in which case it will want the contents to be acceptable to the whole family. Or if it is to be published abroad there may be religious restrictions to consider.

You may not agree with the concept of political correctness, but if your client raises the issue and you want the commission you have to acknowledge the client's rights.

Working from a brief

While inspiration and ideas for cartoons are not always forthcoming, you would think that working from a brief would make life a little more simple. However, you still need to consider your objective and how to communicate it in cartoon form. Once you have a basic concept in mind you should make sure that the various elements – style, lettering, atmosphere, colour – reflect the brief and what the cartoon is trying to say.

Some briefs and scripts are well balanced, giving the artist the freedom to interpret the author's intentions but giving enough detail to make those intentions crystal clear. Mutual respect is what is called for. However, respect goes by the board when the writer of say, a comic strip, includes the entire 600 men of the Light Brigade in every frame and gives them each a 20-word text balloon, making it 16 frames per page. Equally unbalanced is the artist who draws a close-up of Lord Cardigan in every frame saying, 'the men are vociferous tonight!' and cutting the frames back to four. These things do happen and can be resolved with a short email or phone call. Writers don't always have a pictorial imagination, any more than the average cartoonist has a degree in journalism.

A brief from an advertising agency will usually be much more involved and begins with the familiar question 'How busy are you?' Thus on acceptance of the brief you are making an assumed commitment to a deadline. Unlike the comic industry, there is more than just an editor involved in agency briefings. If you're lucky some staff member will have roughed out a visual and already have their client's approval before you get the brief. Otherwise, you may have to submit a series of rough scamps that will require the approval not only of advertising agency personnel but also their clients and this could take several days. Be sure you know what is expected of you. Are the drawings rough layouts with little detail, or detailed pencils? Is the artwork for a magazine, in which case 300 dpi in Photoshop will suffice, or is it for a 48 sheet hoarding that requires the vectored line of the Illustrator software? When agreeing a deadline make sure to factor in sufficient time in case the 'client' sits on it for a few days and leaves you the last three hours on

A typical script from a comic looks something like this.

THE SCALY ONE

```
PIC 1. Large frame.
The giant monster,60 feet tall, dripping wet and
covered in slimy weed, crawls from the harbour
and attacks a quayside crane. People run in terror
except for Bruce Macintyre who looks out from the
wheelhouse of his tugboat. He is a rugged 25yr old
in seamans sweater & jeans
```

TEXT;

SFX Scaly... RROOAAARRGH!

 Bruce That crane should keep it busy long enough
 for me to slip my mooring...!

pic 2.

The tug churns past the monster who catches sight of it from the corner of one of its eyes. Bruce rams the tugs throttle wide open

TEXT;

 Scaly.... HURR??

 Bruce... Drat! It's spotted us!

Friday to finish both illustrations because they've booked the printer. Expect changes and amends!

Selling your work

There's a choice to be made between selling your work (as in retailing actual artwork to clients), and selling yourself (as in promoting your abilities). In the first place you might draw a series of cartoon greeting cards or newspaper gags which requires a potential client address book and a delivery system. Or you might open a self-promotional website and take out some specialised magazine advertising to point to it. The website can trumpet your claim to talent and back it up with changeable samples. It can restrict the information you give out to one email address or telephone number, or give out all your relevant information in a biography. Both events will require some sort of presentation to meet professional standards. Your cover letter, if any, will benefit from a logo and should always be typed. Records must be kept of your client's address and details, accounts kept for tax purposes, invoices must be printed and issued and that's just from day one.

Most importantly, you must have an idea of your worth. If you are a slow worker it's no use charging by the hour, if you are too quick the client will feel overcharged. I have found the simplest way is to have a basic charge for say an A4 black and white illustration and vary this

A blank invoice, produced on the computer, showing the necessary elements to be included.

accordingly – if there is to be colour added, if the content is going to take time, if it's for a national ad campaign or the local sweet shop. (I once had a quote turned down because I didn't charge enough.) The best way to evaluate a job is to ask the client if there is a budget. No doubt the client will understate the sum by some small degree to find out where you stand and bingo! there's a basic fee that only needs fine tuning. For instance, is the job going to be in black and white or colour; what is it going to be used for; is the fee going to be all inclusive; is it exclusive of VAT; is it the first British copyright; and will there be any royalties?

Always ask to see a full brief and make sure you grab some thinking time.

Creating character

Faces and expressions

The human face is the first thing that we recognise as infants and from that moment on, facial expressions become an important aspect of our daily lives. We have to read and interpret hundreds, perhaps thousands, of them every day, all of which are a subtle combination of brows, eyes and lips. In addition, there are sounds, smells and gestures and these are particularly challenging to portray in a cartoon.

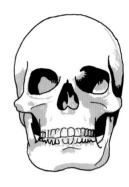

The skull upon which all emotion hangs.

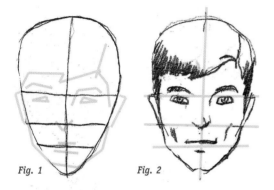

Fig. 1 Fig. 2

Expressions

First you need a head. A slightly pear-shaped oval (see fig. 1) forms the basic shape for the head. To keep the face symmetrical, you need vertical and horizontal bisecting lines to fix the position of the nose and the eyes. Another bisecting horizontal line, drawn between the 'eye-line' and the chin, gives the position for the nostrils. Draw one more bisecting horizontal line between the nostrils and the chin to get a position for the lips. The eye-line and the nostril-line, when carried to the edge of the face, will indicate where the ears might go (see fig. 2). This simple formula works well as a basis from which to develop a convincing cartoon face, using deliberate distortion and exaggeration for comic effect.

As well as facial expression, a well-placed hand and wisp of hair help to tell the tale.

ANXIOUS

Happy

Surprised

Angry

Calm

Suspicious

Sad

Afraid

Simple basic expressions are shown on the balloon faces and as they might look on a realistic face, then slightly lampooned as an ugly little brother. Note that the division ratios that define the position of the features apply to all three of the characters' faces.

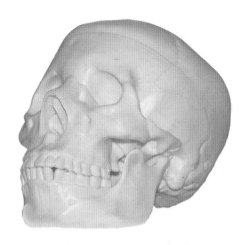

The female skull is generally more delicate and lighter than the male skull, which has a larger jaw and heavier brow and forehead.

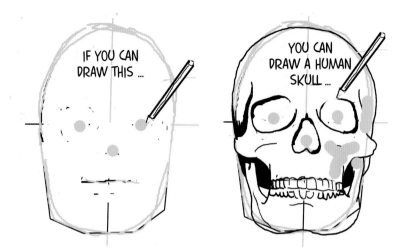

IF YOU CAN DRAW THIS ...

YOU CAN DRAW A HUMAN SKULL ...

AND ONCE YOU HAVE BECOME FAMILIAR WITH THE SKULL, ITS CAVERNOUS EYE SOCKETS AND ITS TRIANGULAR NASAL ORIFICE ...

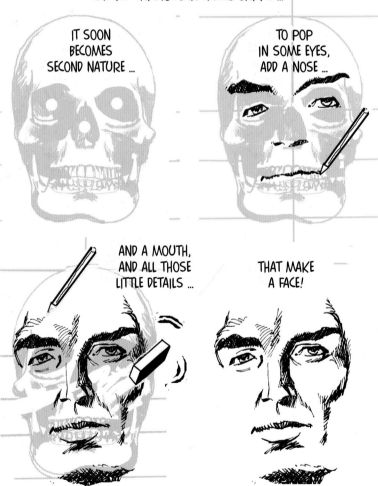

IT SOON BECOMES SECOND NATURE ...

TO POP IN SOME EYES, ADD A NOSE ...

AND A MOUTH, AND ALL THOSE LITTLE DETAILS ...

THAT MAKE A FACE!

The human skull

Even a limited knowledge of facial contours will help you to produce a convincingly life-like head. Take a look at the human skull (above), and notice the prominence of the jaw area and the large size of the eye sockets. Those deep sockets contain only 75 per cent of the eyeball; the other 25 per cent will protrude to make the eyelids convex in shape. Although it's a predominately rounded object, the skull also has flat planes on the sides of the jaw, beneath the eyes, and again on the temples.

However, cartooning is supposed to be fun and at this stage I think it's best and simplest to use a pear-shape as a starting point. This shape works for male and female, young and old, as seen on these pages.

One trick is to become familiar with the skull from all angles (buy and study a good-quality toy skeleton) until you can automatically draw a face around the mental image that you project onto your paper. Once you have the pear-shaped starting point fixed in your mind and can visualise the skull within it, try tilting the whole thing at a few unlikely angles and draw over

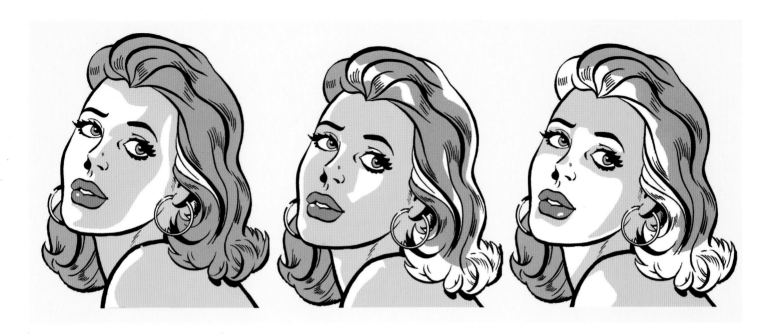

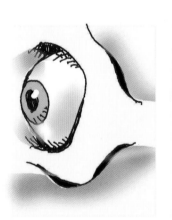

The first face is lit from the front and to the left with reflected light on the opposite side. The middle face is lit directly from the left, and the third face from in front and below.

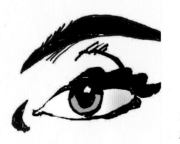

These front and side sketches show the protuberance of the eye and the resulting curve of the eyelids.

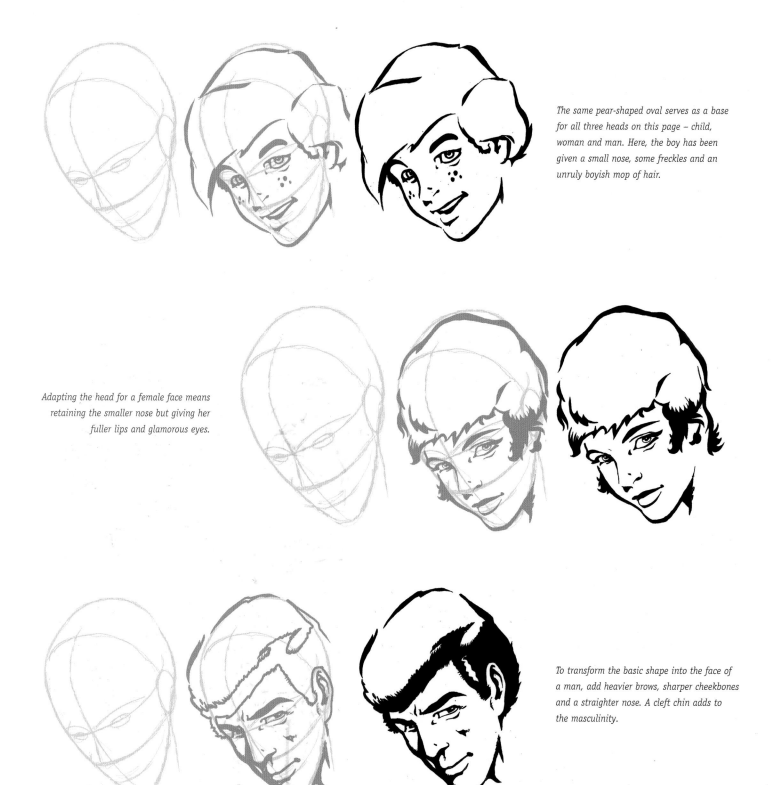

The same pear-shaped oval serves as a base for all three heads on this page – child, woman and man. Here, the boy has been given a small nose, some freckles and an unruly boyish mop of hair.

Adapting the head for a female face means retaining the smaller nose but giving her fuller lips and glamorous eyes.

To transform the basic shape into the face of a man, add heavier brows, sharper cheekbones and a straighter nose. A cleft chin adds to the masculinity.

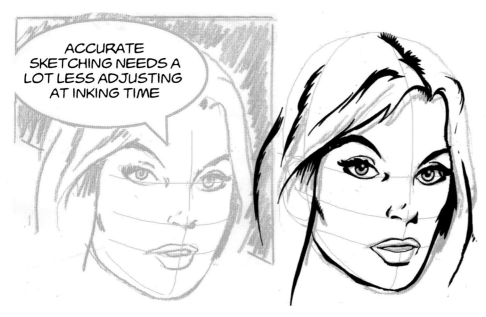

ACCURATE SKETCHING NEEDS A LOT LESS ADJUSTING AT INKING TIME

When you are happy with your pencil sketch, continue with the inking stage. The pencil sketch (far left) works, even though the left eye is slightly out of position, so this is retained for the ink drawing.

them. Keeping the character's eyes fixed on the 'reader' will ensure that the head tilt is not so acute that it distorts the features. It should also allow you to show that at certain angles, with the eyes on the reader, the whites of the character's eyes are either above or below the iris – adjusting the amount and position of this white part can help you to display emotions such as menace, fear, surprise and shock.

Having drawn your head, you'll no doubt want to enhance it with some dramatic shadows. If so, draw the three dimensions of the head as you might draw a sand dune or a rocky outcrop. See it not as a pink and fleshy globe but as a solid, faceted object and block in the shadows with solid tones that contrast with the light areas to emphasise form. Your boldness with the brush might pleasantly surprise you.

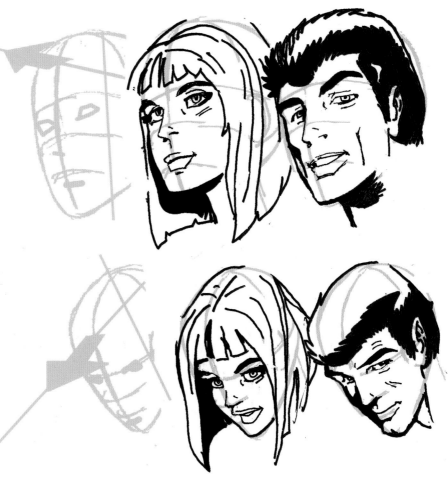

These three drawings show how tilt affects the head. The slight tilt of the head leaves the man's hair unmoved. The woman's long hair, however, would obscure her face because of gravity, were it not for artistic licence.

Adult comic characters

It's fun creating over-the-top comic characters aimed at adults. Such characters require a different approach, moving away from matchstick figures, dividing lines and basic anatomy. Try creating a character from a different starting point – a foot, an arm, or a hand – and then visualising the proportions that lead on from this. By visualising the finished drawing before you start, you'll find that your sketch is more balanced and fluid than when you were busy visualising and drawing matchstick figures to perfect their anatomy.

If this drawing was in a realistic style (like the 'Amanda' cartoon opposite) it might be viewed as lewd and distasteful. As it has been drawn by a cartoonist, the concept becomes more innocent and fun-filled. It was fun creating this over-the-top glamour girl. This character was built outwards from the centre of attention – the breasts – and the body was then allowed to sweep away from beneath in a soft curve. This in turn, meant that her head had to lean forwards as a counter-balance. So having drawn two oval breasts, the rest of the figure fitted in without the need for spines and pelvises, and the results were physically entertaining if not exactly accurate.

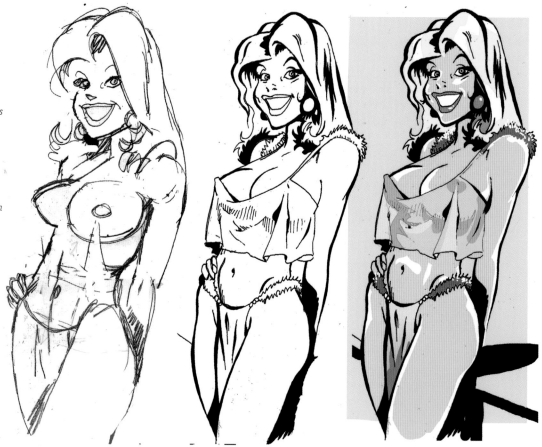

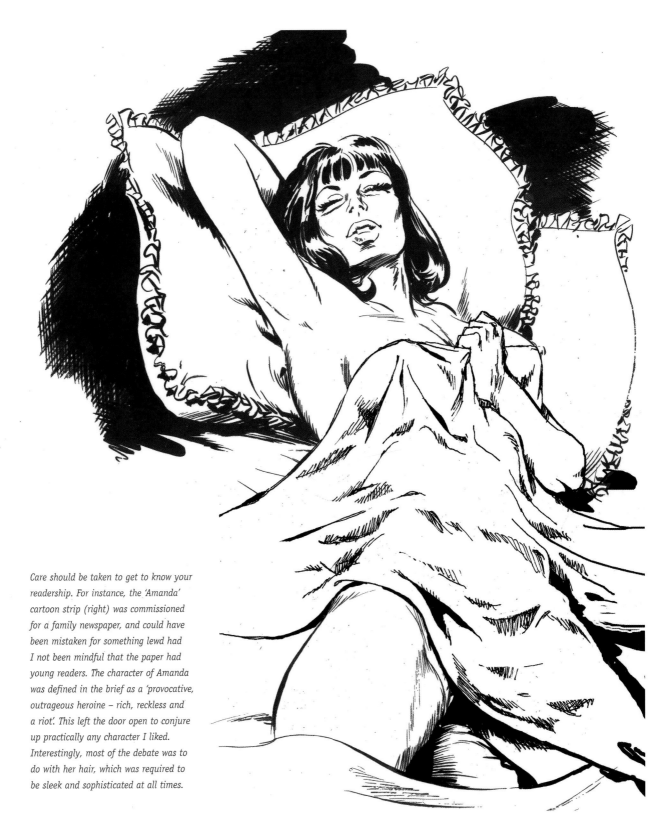

Care should be taken to get to know your readership. For instance, the 'Amanda' cartoon strip (right) was commissioned for a family newspaper, and could have been mistaken for something lewd had I not been mindful that the paper had young readers. The character of Amanda was defined in the brief as a 'provocative, outrageous heroine – rich, reckless and a riot'. This left the door open to conjure up practically any character I liked. Interestingly, most of the debate was to do with her hair, which was required to be sleek and sophisticated at all times.

An adult cartoon strip for a financial newspapers with a highly defined readership – financial advisers. The brief was to try to insert humour and the occasional caricature into an otherwise dry subject. This proved to be easier than imagined when the advice from one of the advisers turned out to be 'never eat yellow snow!' It was also required that the characters were not too grotesque. The cartoon needed to be turned around in six to eight hours so that its content remained up to the minute. It was therefore drawn in a simple wire-line style.

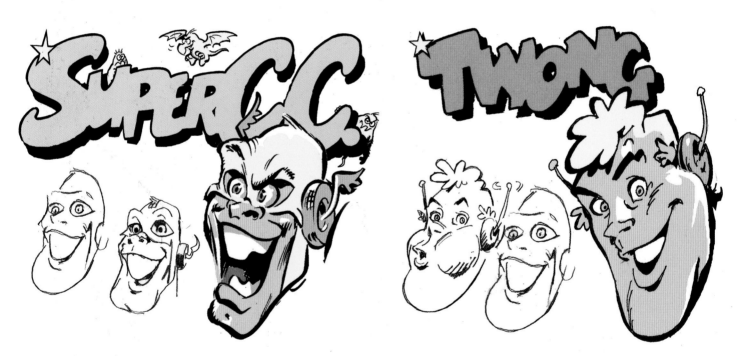

Super CC was created for Custom Car magazine and as soon as I understood the reader's mind set, I decided to make him an anti-hero – always getting things wrong and ending up in a mess. I've found that the wide banana-shaped chin, used in the rough pencil sketch, works for all my lampoon characters. Formed from rounded and vigourous sweeps of the pencil, it seems to infuse the figures with a kind of energy that survives the inking process. For this character, the chin was squared up and cleft.

Twong is a Citizens' Band hero – twong is the sound that his CB aerials make when plucked. The 'wide banana' chin shape of the basic pencil sketch suffices for this character too, but here the chin is left rounded, the nose turned up a bit and a tuft of hair tops his golden head.

When drawing lips, you might find it easier to draw the white of the teeth first and then draw the lips around it. It works much better than drawing a mouth and trying to fit the white bit in the middle. If the mouth is closed, just draw the lip-line as accurately as possible, then mount the top lip first if it's a woman (because it defines the pucker of the mouth), and add a slightly thicker lower lip. For a man, you need to draw a thicker lip-line (no top lip is required) and a jutting lower jib. A tiny white light on the eye will bring it to life. We all know this, but suprisingly a dash of grey/blue under the eyeball opposite the white dot works just as well.

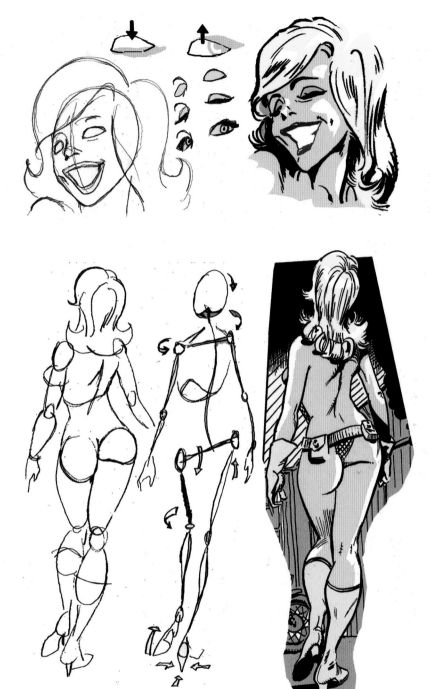

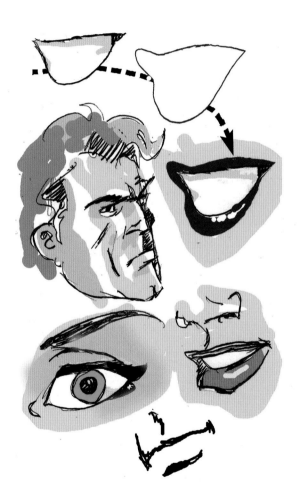

Tina Tailpipe was created for SuperBike magazine. Note that the eye shapes on the pencil sketch are basically the same size regardless of whether the finished eyes are open or closed. Only the addition of lashes on the top or bottom of the eye shape makes the difference. The planking on the shed in the background of the full figure was deliberately slanted to emphasise her stance.

Hands and feet

Even Michaelangelo would have to agree that the hand is the most complex part of the body to draw, more expressive and flexible even than the face. In cartoon form, the dramatic hand can be emphasised by dressing it in gloves or gauntlets.

Both pairs of hands were drawn from simple shapes. This is the key to drawing successful hands (see opposite and page 64) and will provide a base to help you achieve structure.

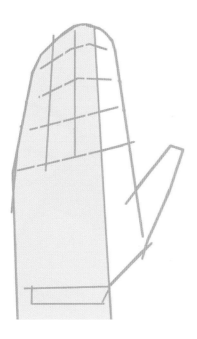

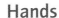

When drawing a flat hand, the width of the wrist is roughly equal to the palm minus the thumb and index finger.

Hands

Drawing hands convincingly is very difficult because of their flexibility and expressive nature. Hands play a vital role in portraying character and it is worth practising drawing them – the more time you spend studying hands, the more confident you will become.

It is helpful to bear in mind one or two rules of proportion when sketching hands.

On a flat hand, the wrist is roughly equal in width to the palm minus the thumb and index finger (see left), and the three remaining fingers project onwards from the extended forearm/wrist. Although the finger bones begin at the wrist, they are obscured by the palm for half their length, after which they divide into their separate fingers (see below left). The knuckles do not occur in a straight line across the fingers, but in a series of gentle curves. There are three knuckles on each finger after the wrist, but only two on the thumbs (see below centre). The fingers divide slightly above the base knuckles, not at the knuckle (see below right).

Finally, if you are drawing the hand in the same frame as the face, the length of the hand is a little longer than the distance between the eyebrow and the chin. This applies to both male and female figures, even though the female hand is usually smaller and more delicate.

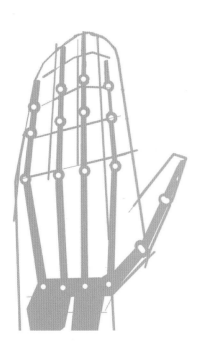

The finger bones begin at the wrist, but they are obscured by the palm for half their length.

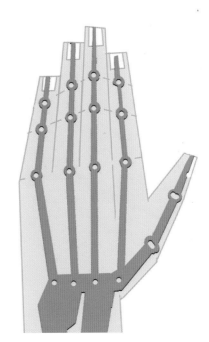

The knuckles do not occur in a straight line across the fingers but in a series of gentle curves.

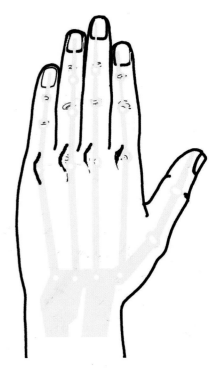

The fingers divide slightly above the base knuckles, not at the knuckle.

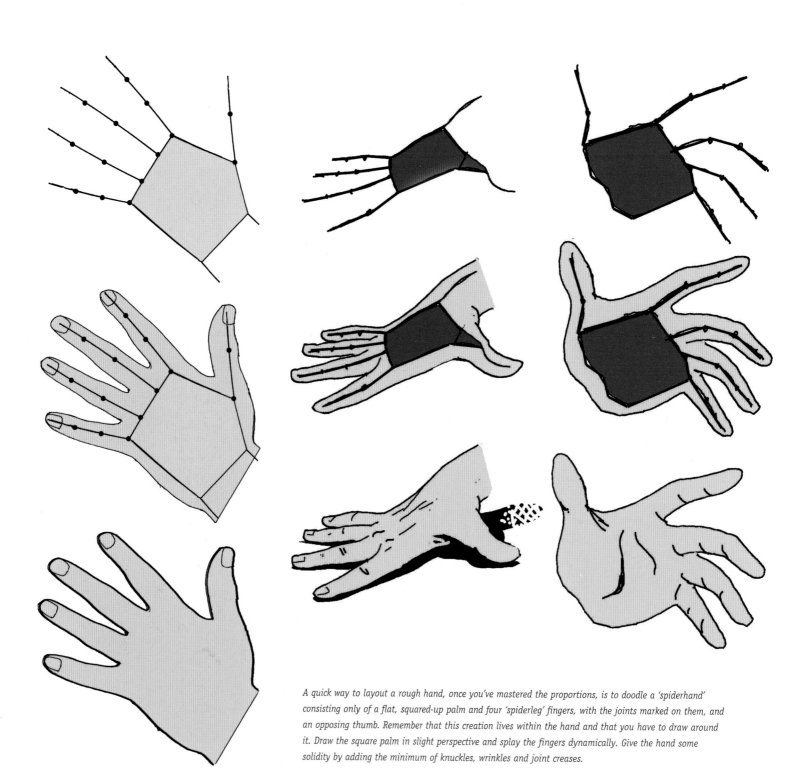

A quick way to layout a rough hand, once you've mastered the proportions, is to doodle a 'spiderhand' consisting only of a flat, squared-up palm and four 'spiderleg' fingers, with the joints marked on them, and an opposing thumb. Remember that this creation lives within the hand and that you have to draw around it. Draw the square palm in slight perspective and splay the fingers dynamically. Give the hand some solidity by adding the minimum of knuckles, wrinkles and joint creases.

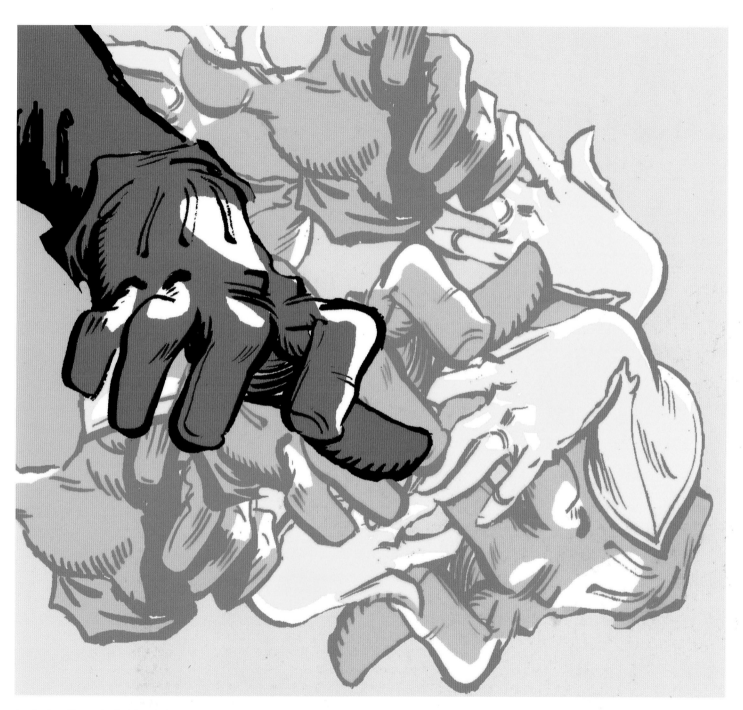

A collection of intertwined, sinister-looking, gloved hands, illustrates their expressive nature.

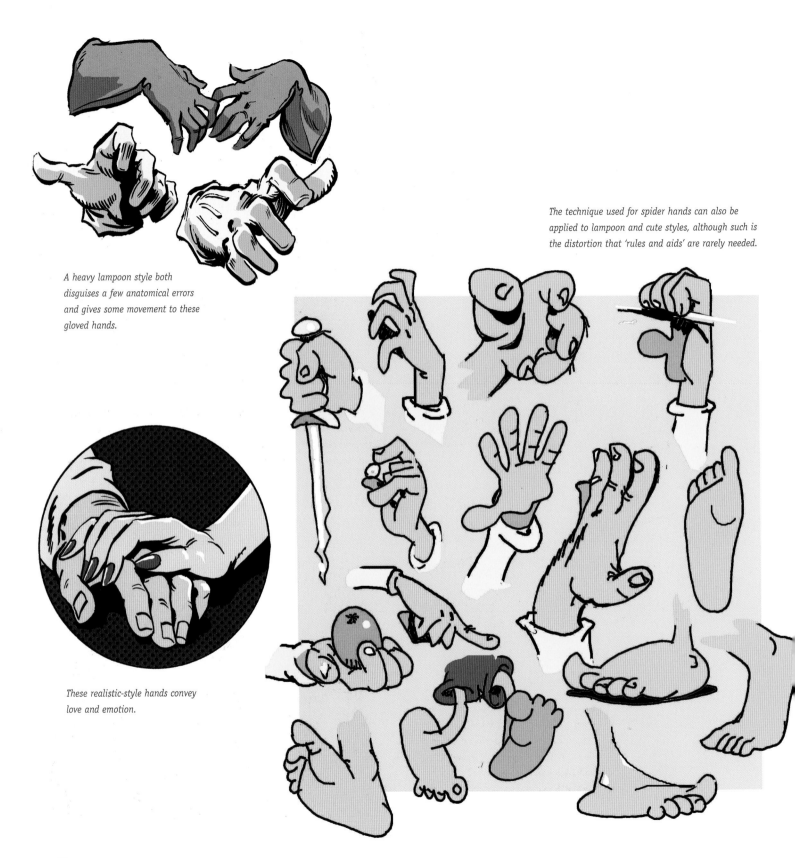

A heavy lampoon style both disguises a few anatomical errors and gives some movement to these gloved hands.

The technique used for spider hands can also be applied to lampoon and cute styles, although such is the distortion that 'rules and aids' are rarely needed.

These realistic-style hands convey love and emotion.

Feet

The set of rules that apply to the hands also apply to the feet, though in different proportions. This time, only the big toe is added to the straight line that roughly forms the parallel sides of the sole, which is four toes wide.

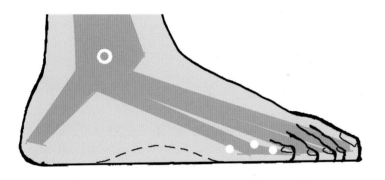

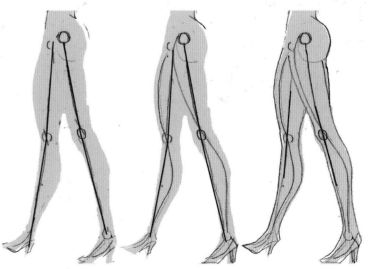

Feet are strange things to draw – especially when a figure is standing still and there is no action to divert the eye away from their feet. If you can't find a foot model for a digital reference photo or sketch, go for the next best thing, a shoe. A well-worn shoe holds the memory of its owner in its shape well enough to suggest how a posed foot might look.

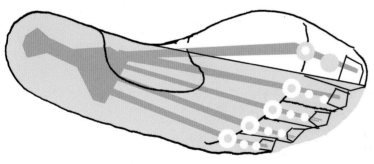

A quick way to draw legs in profile is to draw a straight leg and mark the knee position in the centre. Then draw a gentle S curve from the front of the hips through the knee to the ankle. The outline of the leg will closely parallel the straight and curved lines that you have marked.

Fabric and clothing

A good rendition of fabric can made or break the believability of a cartoon, but much depends on its context. If it's a crumpled sheet on a bed in the background of a fight scene, it will only need to be recognised as such. But if the bed is the hiding place for a murder weapon, the folds of the sheet will play a crucial role in framing the scene and their depiction is much more important.

To simplify the depiction of fabric for the purpose of cartooning, it can be divided into three main forms: crumpled, kinked and draped. The crumple effect is a random disturbance of a fabric, the kink is a compression fold (like the folds in bellows) and the drape is formed by the effect of gravity upon a fabric.

Crumpling, as applied to a tablecloth, sheet, or a fluttering flag, can be anything from slightly to heavily defined. As with the other fold types, the definition will depend upon the media and colour used. A black-and-white rendition might require simple brush strokes or cross-hatching, while a colour rendition can rely entirely upon the use of tone and shading.

The kink, as seen in a tube of fabric, can be applied to the top of a sock, the inner elbow of a sleeve, the waist of a gown, a pillow, trouser legs and metal or plastic tubes – the same basic folds occur in all of these things.

The drape is the entirely natural and elegant effect of gravity on a pliant material and the fall will depend upon how the fabric is restrained. A gathered curtain, for example, will fall in parallel folds that tend to 'ungather' at the base and straight lines might be involved in drawing this. An object draped in fabric, however, will tend to involve gently curving lines. In a highly dramatic drawing, such as a superhero shredding his shirt, the drama can be emphasised by harsh, zigzag folds in the character's clothing, although care should be taken to soften the zigzags to prevent the material looking too stretchy.

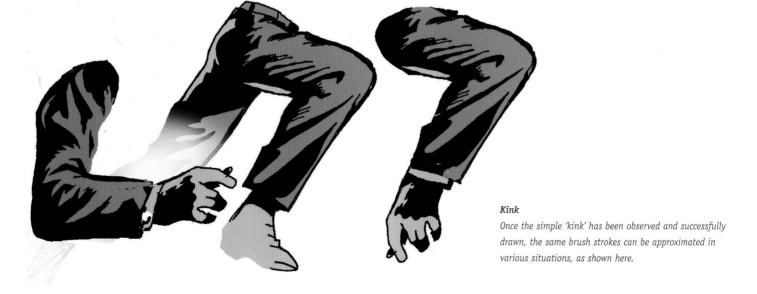

Kink

Once the simple 'kink' has been observed and successfully drawn, the same brush strokes can be approximated in various situations, as shown here.

TIP

It can be worthwhile keeping a scrapbook of interesting fabric folds until you become familiar with illustrating the subject.

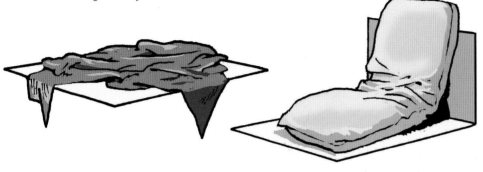

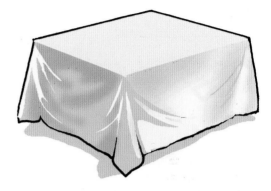

Crumple

Most cartoonists would agree that for general fabric effects there is no great need for accuracy, just a few lines, as here, to suggest folds.

Kink

This kind of fold, usually in a tube of fabric, can be formalised into a pattern that the illustrator can use repeatedly, in different situations.

Drape

The drape depicts folds in an anchored fabric which are made elegant and somewhat predictable by gravity.

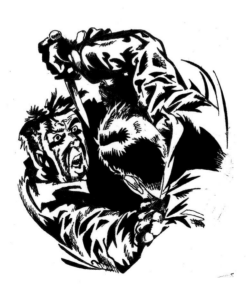

This illustration, drawn with brush and pen, incorporates heavily defined concertina folds in the fighters' sleeves. This assists with the perspective and adds movement and dynamism to the image. Note how the sharp glint of the knife blade is emphasised by the solid, dark tones behind it.

Posture

Posture is body language. When you want to emphasise a facial expression it is useful to keep the body posture neutral, but if there is an opportunity to draw a full-length character you can let the posture do the talking. Much like actors in silent movies, our heroes can offer at-a-glance postures that suggest rage, jubilation, anguish, sorrow, fatigue, pain, cowardice, speed and all the other emotions that are part and parcel of the human condition (even if they are animals like Donald Duck).

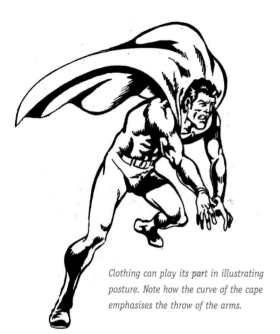

Clothing can play its part in illustrating posture. Note how the curve of the cape emphasises the throw of the arms.

Heroic types

The trick is to exaggerate the posture of your character until it screams (or squawks) the required message at the reader. This is also called dramatic effect. Most of the time, beautiful women and handsome men are the archetypal comic-book heroes, though in some cases they become merely wasp-waisted, top-heavy sex symbols on incredibly long legs, while the men are micro-nosed Adonises with thick curly locks or muscle-bound baldies in stretch tights. There are also the anti-heroes – usually a mutant misunderstood monster, often a victim of radiation, who manages to grab the reader's sympathy while wiping out half the planet. You'll have the essential ingredients to create a hero if you remember that there's no good without evil to compare it to.

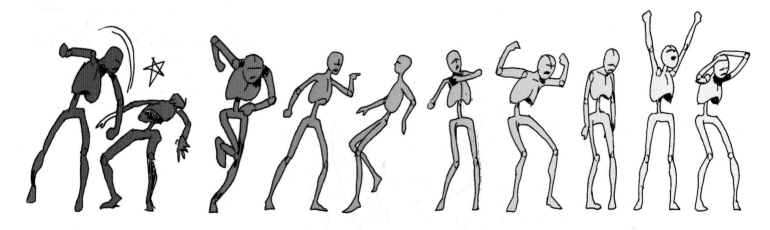

These small figures represent a few of the many hundreds of emotional 'body statements' that the cartoonist uses to tell a tale. Note that none of the figures have both feet off the ground. Try tracing them and raising their feet into airborne positions. You will see that each one becomes more than just emotional – they become humorous too. Any figure with both feet off the ground suggests movement and it is advisable that the body posture also suggests the direction of the movement.

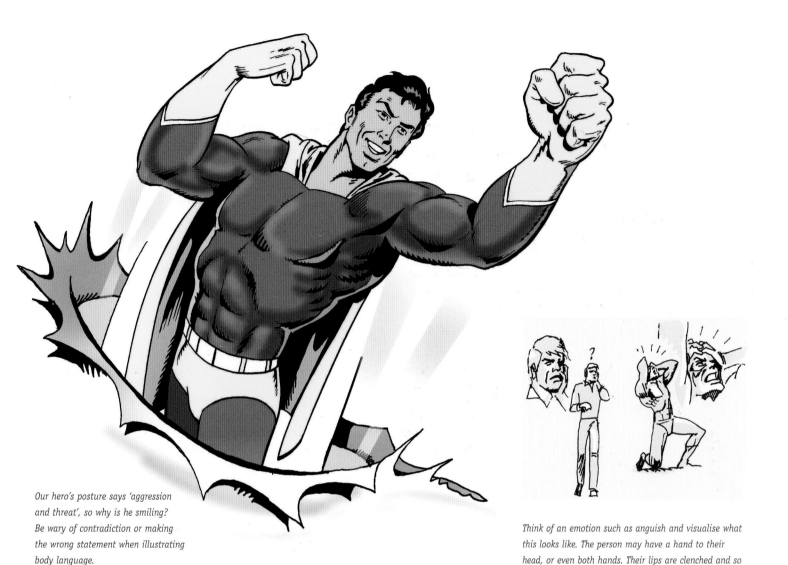

Our hero's posture says 'aggression and threat', so why is he smiling? Be wary of contradiction or making the wrong statement when illustrating body language.

Think of an emotion such as anguish and visualise what this looks like. The person may have a hand to their head, or even both hands. Their lips are clenched and so too are the teeth; the mouth is snarling. By deliberately exaggerating the pose (and the muscles), you will produce a dramatic, superhero body statement.

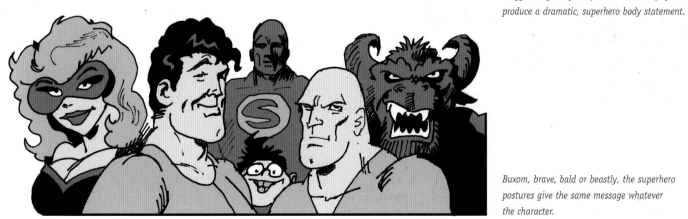

Buxom, brave, bald or beastly, the superhero postures give the same message whatever the character.

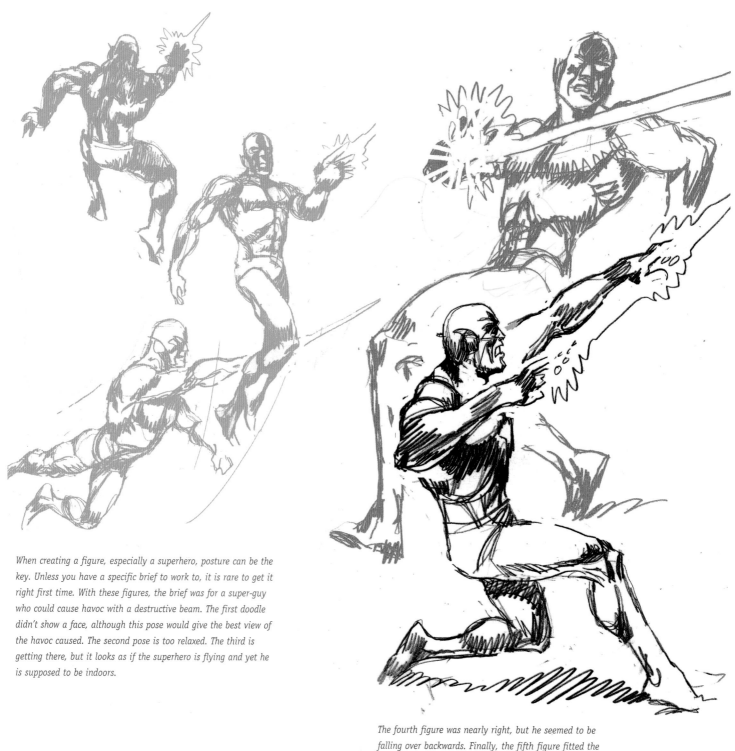

When creating a figure, especially a superhero, posture can be the key. Unless you have a specific brief to work to, it is rare to get it right first time. With these figures, the brief was for a super-guy who could cause havoc with a destructive beam. The first doodle didn't show a face, although this pose would give the best view of the havoc caused. The second pose is too relaxed. The third is getting there, but it looks as if the superhero is flying and yet he is supposed to be indoors.

The fourth figure was nearly right, but he seemed to be falling over backwards. Finally, the fifth figure fitted the brief. Aggressive yet in control, powerful yet graceful, masculine but well-balanced.

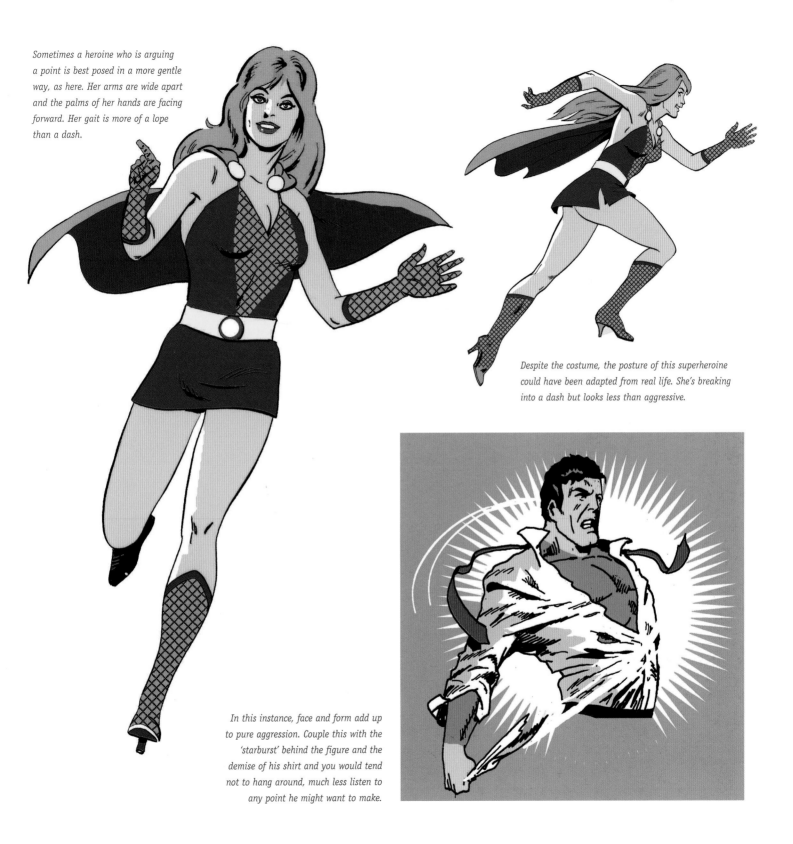

Sometimes a heroine who is arguing a point is best posed in a more gentle way, as here. Her arms are wide apart and the palms of her hands are facing forward. Her gait is more of a lope than a dash.

Despite the costume, the posture of this superheroine could have been adapted from real life. She's breaking into a dash but looks less than aggressive.

In this instance, face and form add up to pure aggression. Couple this with the 'starburst' behind the figure and the demise of his shirt and you would tend not to hang around, much less listen to any point he might want to make.

Animals

Just as body language is the key to depicting human figures, the same is true for animals. Smooth, finished line work is often required for animals and it is better to get some kind of flow going during the pencilling stage so that carefully brushed key lines have something 'fluid' to follow.

The brief for this character was for 'a dog with attitude'. Squaring the teeth as opposed to making them pointed ensured that the 'attitude' was cheeky rather than dangerous.

In the real animal kingdom there is more 'tooth and claw' than 'cute and cuddly'. It is usually the cartoonist's lot to erase the naturally unpleasant tendencies of an animal and imbue it with much more recognisable and acceptable human traits. There are various types of animal portrayal, from the well-recognised 'Disneyesque' to the more sinister Japanese manga style, with lots of variations in between.

For a 'cute' look, try enlarging the head, shortening the limbs and making the eyes and ears of the animal disproportionately large – the body language should be that of a shy two-year-old child. Preliminary doodles should be made up of sweeping lines and plump circles. If you are animating the character, try imagining that it has cute lips. Finished inks can be wire-line with a technical nib or brush-worked to give an overall smoothness.

For a realistic style, the artwork is best drawn from a photographic reference. It is worth noting that in this style of cartoon, animals don't have human-type eyebrows, they only walk on their hind legs under protest, and they don't talk.

The lampoon style gives the cartoonist the best opportunity to portray animal traits, allowing free rein to depict walking, talking, cussing, biting, singing, dancing, fighting, stealing, mugging, spitting, and all the other facets of human behaviour that we hold dear.

The drawing of the tiger attacking a buffalo has 90 per cent of the action built into its whiplash tail.

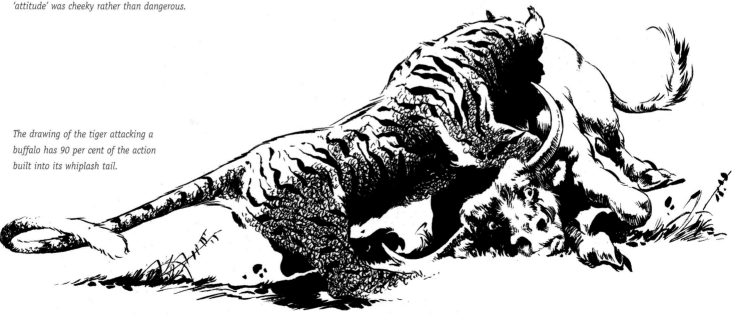

This cute-style beaver was based on a series of pencilled loops that not only gave the character the required plumpness but an energetic flow as well.

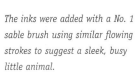

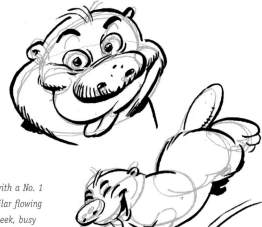

The inks were added with a No. 1 sable brush using similar flowing strokes to suggest a sleek, busy little animal.

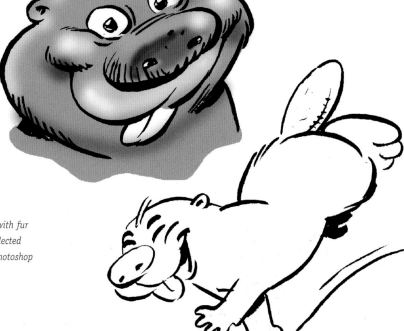

The beaver is a water-based animal with fur that is wet and shiny so this was reflected in the application of the colour by Photoshop 'airbrush' to give a smooth finish.

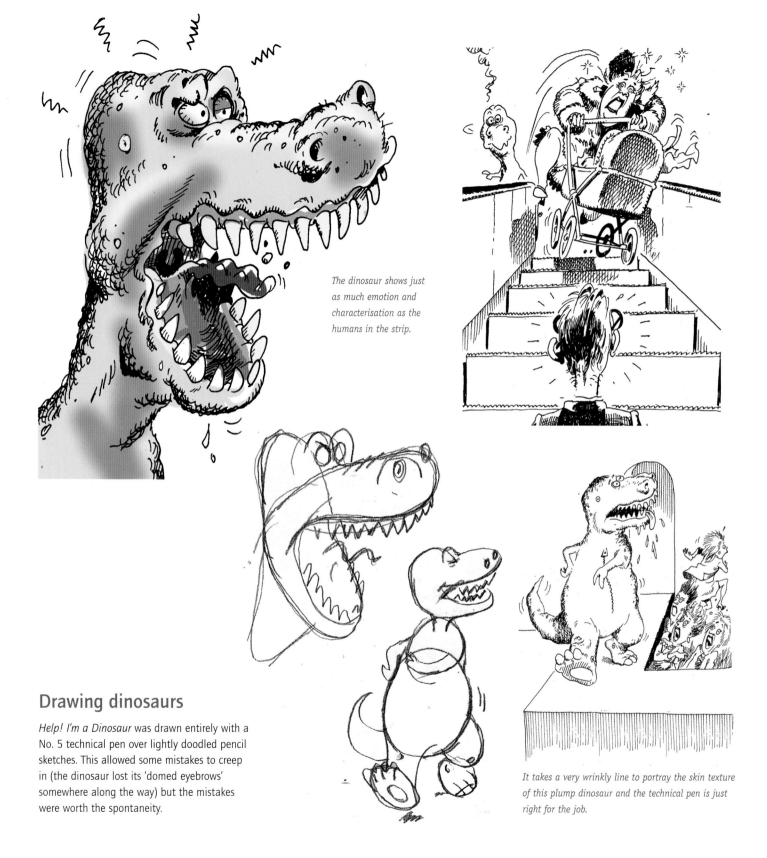

The dinosaur shows just as much emotion and characterisation as the humans in the strip.

Drawing dinosaurs

Help! I'm a Dinosaur was drawn entirely with a No. 5 technical pen over lightly doodled pencil sketches. This allowed some mistakes to creep in (the dinosaur lost its 'domed eyebrows' somewhere along the way) but the mistakes were worth the spontaneity.

It takes a very wrinkly line to portray the skin texture of this plump dinosaur and the technical pen is just right for the job.

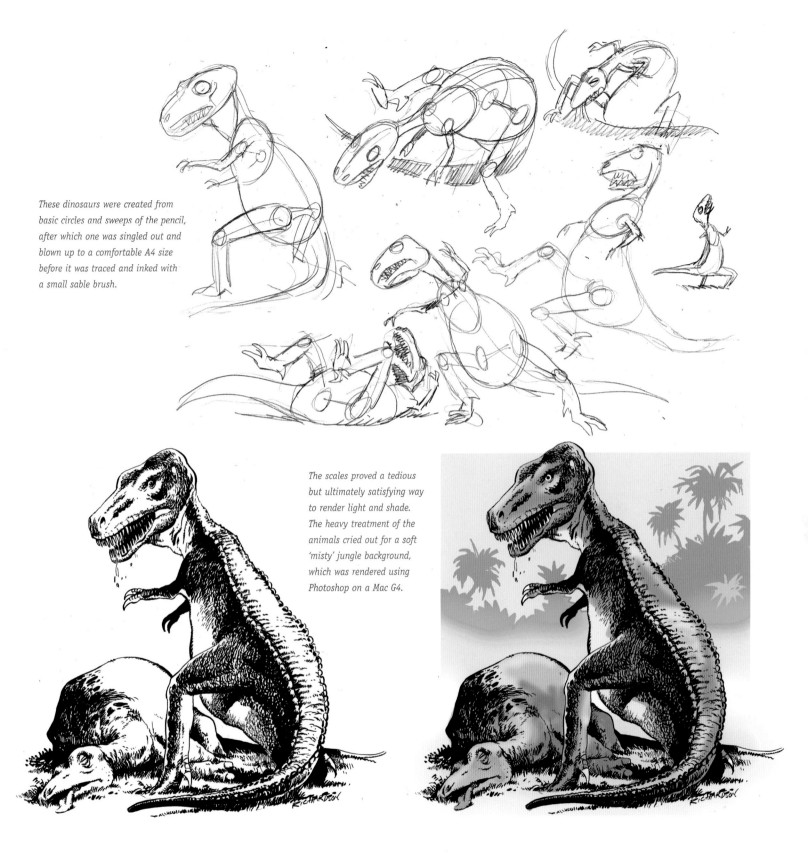

These dinosaurs were created from basic circles and sweeps of the pencil, after which one was singled out and blown up to a comfortable A4 size before it was traced and inked with a small sable brush.

The scales proved a tedious but ultimately satisfying way to render light and shade. The heavy treatment of the animals cried out for a soft 'misty' jungle background, which was rendered using Photoshop on a Mac G4.

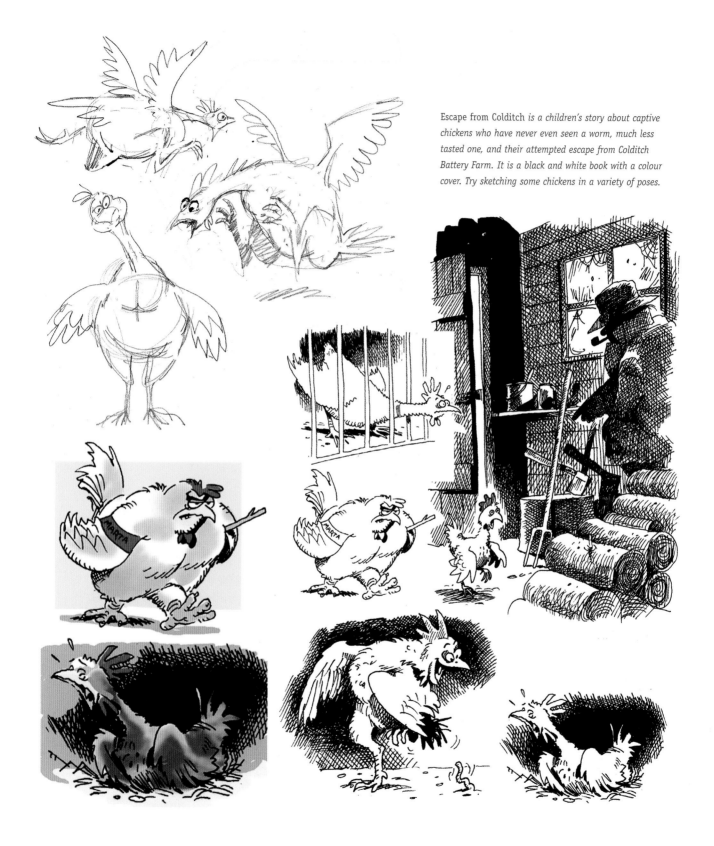

Escape from Colditch *is a children's story about captive chickens who have never even seen a worm, much less tasted one, and their attempted escape from Colditch Battery Farm. It is a black and white book with a colour cover. Try sketching some chickens in a variety of poses.*

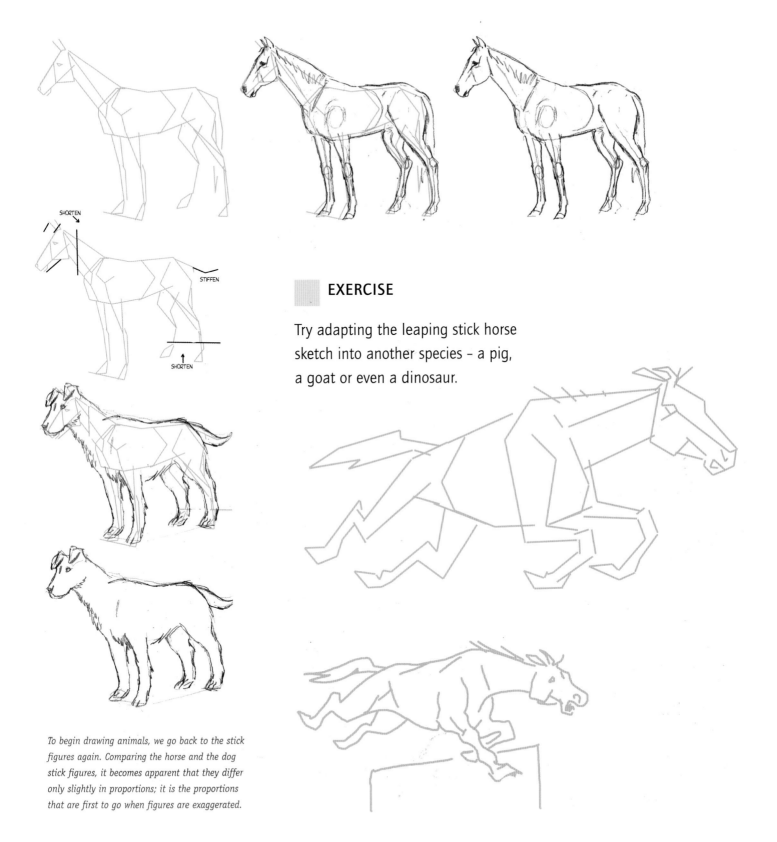

EXERCISE

Try adapting the leaping stick horse sketch into another species – a pig, a goat or even a dinosaur.

To begin drawing animals, we go back to the stick figures again. Comparing the horse and the dog stick figures, it becomes apparent that they differ only slightly in proportions; it is the proportions that are first to go when figures are exaggerated.

Inanimate objects

Drawing a cartoon object, be it a vase, a car or a tree, requires some forethought. If the object is not essential to the plot and is simply a background filler, then it can be drawn with just a few brushstrokes, hatched or cross-hatched, and kept simple to avoid distracting the eye from the foreground. If an object is essential to the story, however, it is sometimes advantageous to show its scale by placing it next to a more familiar object, such as a tea cup or a hand.

For this simple-looking burger drawing it was extremely important that the ingredients, from the sesame seeds atop the bun to each item in the layers within it, were reflected accurately and not exaggerated.

To show scale, it helps to place an inanimate object next to a more familiar object, such as a hand.

When drawing an object such as a tree, simplicity is the rule (fig. 1), otherwise you can get carried away with the detail of the bark and the never-ending bifurcation of branches and twigs.

If you are working on a computer there is the possibility of sketching and scanning in just a single posy of leaves and cloning them into a whole tree (fig. 2). But if you are going to colour your work, remember to colour the posy before you start cloning or you will have to colour all 5,247 clones individually! There is always the fallback of the digital photograph of a tree or bush in silhouette that can be adapted to drop into your background art.

It is worth keeping any quality photographs of trees, buildings, animals, street lamps and signposts, and putting them into a scrap book or file for possible future use.

Fig. 2

cloning

Fig. 1

The most common inanimate object in society is probably the motor car. It is difficult to draw for three main reasons: it has few straight lines, four round wheels, and a shiny surface. It helps to bear in mind that windscreens usually reflect the buildings alongside due to their curve. Bonnets reflect the windscreen, while side windows and the car's flanks reflect horizontally. The wisest option is to draw direct from photographs and use flat colour.

With digital cameras now widely available, it is worth looking at the possibilities they can offer. Photographs of practically anything in the public domain can be used for reference, but not for publication. Trains, boats, planes, cars, buses, street furniture and bicycles (always hard to get right) can all be fed through a camera and a computer, hiked up on contrast and traced from a lightbox to achieve a professional result. Or the reference can be used as a base for a cartoon version of the real thing – a car caricature, no less.

Those who wish to take it a stage further can utilise such programs as Photoshop and Illustrator to add colour.

Using a pen carefully for the curves will reward a tracer with a crisp likeness. Alternatively, use a small brush to achieve a cartoon version.

Lettering design

Comic strips comprise pictures and words, and while the words are a vital element, the whole story hangs by its title logo – making this the most important word. For a newspaper strip, the title is usually a typeset line in the margin. For a weekly comic, a title becomes a distinctive logo. And for a one-off graphic novel or comic that bears its own colour cover, the title can range from a typeset word to an exquisite piece of art in its own right.

The use of the purple drop-shadow makes the lettering jump out.

There are still some skilled illustrators and cartoonists who hand-letter their artwork and there's no doubt that their work benefits from their efforts, if only because they allow room for the text and then 'draw around it'. However, it would seem that many cartoonists today allow designers to add the lettering later.

Try applying your own text to your illustrations utilising at least one 'comic' typeface (see right). The text can be scanned, sized and printed to be cut out and glued to the original artwork, or applied as an extra layer using Photoshop. Using the 'type' tool you can create an extra layer over the artwork to carry the type – these layers are moveable. If the type is set to align centrally and input in such a way as to be 'egg-shaped', the 'oval marquee' can be used on the background layer to create a speech balloon, 'cleared' and 'stroked' with an outline, the tail added and the piece of text positioned within the balloon before 'flattening' the image (if preferred). Keeping the text in a separate layer will enable you to make changes to it later on. However, if you are going to be delivering your digital drawings by email, bear in mind that lots of layers will be a drag on your sending speed.

One job that is a challenge when making a strip illustration is the logo. The options are to use straightforward commercial typefaces, such as Times Roman or Helvetica, printed large and subjected to one of the many available computer tweaks, or to sacrifice your deadline by attempting to design a title logo from scratch and build it into your layout, as with the Man Eater logo (see right).

Comic Sans
ABCDEFGHIJKLMNOPQRSTUVWXYZ
abcdefghijklmnopqrstuvwxyz 1234567890
!@£$%^&*()_+?

Optikartoon
ABCDEFGHIJKLMNOPQRSTUVWXYZ 1234567890
!£$%^&*()_+

Whizbang
ABCDEFGHIJKLMNOPQRSTUVWXYZ
abcdefghijklmnopqrstuvwxyz 1234567890
!@£$%^&*()_+?

Comicstrip
ABCDEFGHIJKLMNOPQRSTUVWXYZ
1234567890 ! £$%^&*()_ ?

Squash MN
ABCDEFGHIJKLMNOPQRSTUVWXYZ
1234567890 ! £$%^&*()_ ?

The main Crisis cover lettering was achieved by printing out the word 'crisis' in Impact typeface to the required size and tracing around it with a wavy line, which was later thickened up by 'stroking' it with a few pixels.

The IT'S ALIVE! lettering uses a similar outlining method to that described above, but it was traced with a more jagged line and a thicker 'stroke' was applied.

Telling a story

Cartoon strips

Strip cartooning, or sequential art to give it a proper title, is an acquired skill, often built upon natural talent. Not everyone who can draw can qualify in comics, and certainly not everyone who qualifies in comics can draw. Some artists have expertise in layout, viewpoint, balance and line and their style is secondary to the storytelling. Others draw so well and with such an engaging style that the story becomes almost irrelevant. However, both require a good script.

Writing a script

In strip cartooning there is a golden rule: it is sequential art with added text, not text with added illustration. In other words, if you are writing a script try to keep your text to an essential minimum and leave yourself (or the artist) plenty of space to interpret the plot. This includes limiting the number of frames per A4 page to a sensible six to nine frames rather than ten to twelve. Avoid, if possible, the scenario where two characters indulge in a six-balloon conversation in one single frame, or the situation where there are a group of heroic characters who all appear in each frame with something to say.

Comic strips

There are recognised layouts for comic strips. Begin by establishing the all-important page size (type area) and if this size includes any bleed (the space between the type area and just beyond the page edge). A bled frame is not confined to the type area and the artwork may run off the page.

A page is divided horizontally into banks (rows), which are made up of frames (boxes). You can have from two to four frames comfortably in a single bank, depending on their content. Anymore than this will make an average frame claustrophobic. The exception to this is a single bank newspaper cartoon, known simply as a strip.

You don't need to be a detective to work out that too much text drowns a page of artwork in a sea of type.

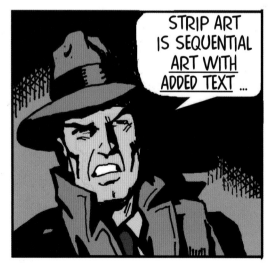

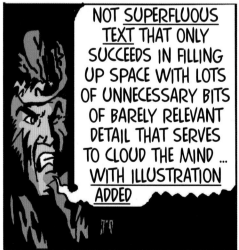

The cartooning industry has its own conventions, recognised layouts and vocabulary. Here are a few of the well-known ones that form the basis of a typical comic strip.

Use of text

The first lettering appears in the logo or title. This can be of set dimensions, as used in a series or set of instalments, in which case space can be set aside for it, or it can be a one-off piece of artwork incorporated into the first page of a comic, which is known as the title page.

Cover artwork

The cover of a comic is usually separate to the interior story pages. Any lengthy text is usually carried in a frame of its own called a text panel while 'signpost' text such as 'suddenly ... And then ... Later ... Back at the ranch ...' Is usually reserved for top panels, captions or base panels. Creating a shadow behind these panels or text balloons gives depth to the page and the technique is called drop shadowing. Close-ups that fill the frame are indicated in the scripts as 'CU' and any sound effects as 'FX' and can include custom lettering, sometimes placed over a flash fx or formalised explosion.

Working with scripts

A script is very straightforward, designed to be read and understood at a glance. It will usually begin with the title of the story as a heading, followed by the page number of the comic and frame No.1. The scene is then described in simple detail and includes the character descriptions and any items important to the story line. From this

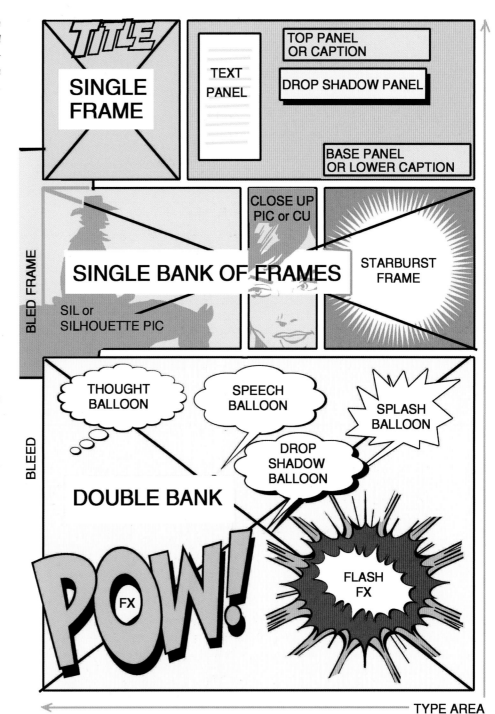

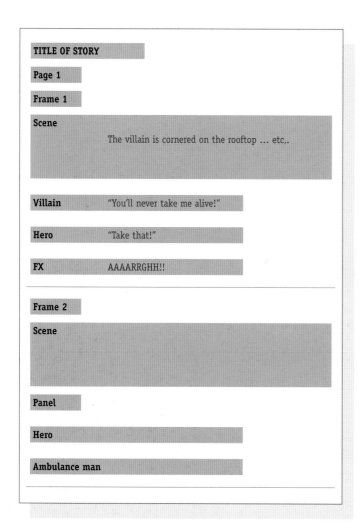

TITLE OF STORY

Page 1

Frame 1

Scene

The villain is cornered on the rooftop … etc,.

Villain "You'll never take me alive!"

Hero "Take that!"

FX AAAARRGHH!!

Frame 2

Scene

Panel

Hero

Ambulance man

A script layout provides the artist with a detailed brief from which he or she can build up a mental storyboard prior to starting work on the artwork.

you can build up a mental storyboard as you read through the full script before starting on the artwork. Next come any text panels, followed by a list of speaking characters' names and what they are saying. The artist needs to know the extent of these texts in order to leave enough 'dead' space for the letterer to use. Publishing houses prefer the lettering to be added later as some artwork may be destined for foreign publication and lettered in a different language. When the introduction and first frame have been set out, subsequent frames should be separated by clear lines. Extra care should be taken over the frame numbers as one mistake will have a domino effect on the rest of the strip.

Drawing from a script

If you are drawing a cartoon strip from a script, the problems are exactly the same but seen from the other side. They are problems best solved by either direct communication with the editor or gentle words with the writer. If by some chance you acquire the perfect script and decide to illustrate it before you have it framed and worshipped by the great unwashed, your first task will be to decide on the sizes of the individual frames. For instance, if the frame demands a detailed medieval castle, do you place a costumed figure in the close foreground with the castle standing on the horizon in its far-off entirety?

Or, do you draw half the castle to give some architectural detail, and add some tiny (well you thought they looked medieval) costumed figures being busy around its walls? Alternatively, do you go straight for the jugular and draw an aerial view of the place?

No contest. The aerial view, although you would have to invent the details, would be the best because it's the most unusual and exciting viewpoint for a cartoon or comic drawing. Your perfect script may even have indicated this already in the 'scene' portion. Perhaps the absolutely perfect script would casually mention this viewpoint but leave the final choice to you (or the artist). Whatever the 'scene' portion or frame description requires, it is best to read through the script and formulate some ideas as to the characters and storyline before attempting frame sizes. A simple pencilled 'CU' against a close-up frame number will denote a smaller frame and simplify the sizing problem.

Page doodles

Now it's time to doodle a few 'thumbnail' pages (about 20 x 25cm/8 x 10in), divide them horizontally into banks – three banks for six to eight frames and four banks for eight to ten frames. When you have checked how many frames there are to the page, begin the rough division of banks into frames, marking the smaller close-up frames as being of potentially variable sizes.

For initial thumbnail sketches, the first frame may benefit from a splash title that could take up a full bank or even two, compressing the remaining frames and requiring careful consideration of which are to be close-ups, medium-sized or large, which are to be 'splashed', circular, cross-cut, frameless, bled and, importantly (because it usually requires a level edge to top or bottom of the frame), which frames will have panels.

Once you have determined your frame layout and numbered each frame on your doodled notes you are ready to sketch in some of those scenes that have been half-formed in your mind since you first picked up the script. This is why page thumbnails are best sized at around A7, which

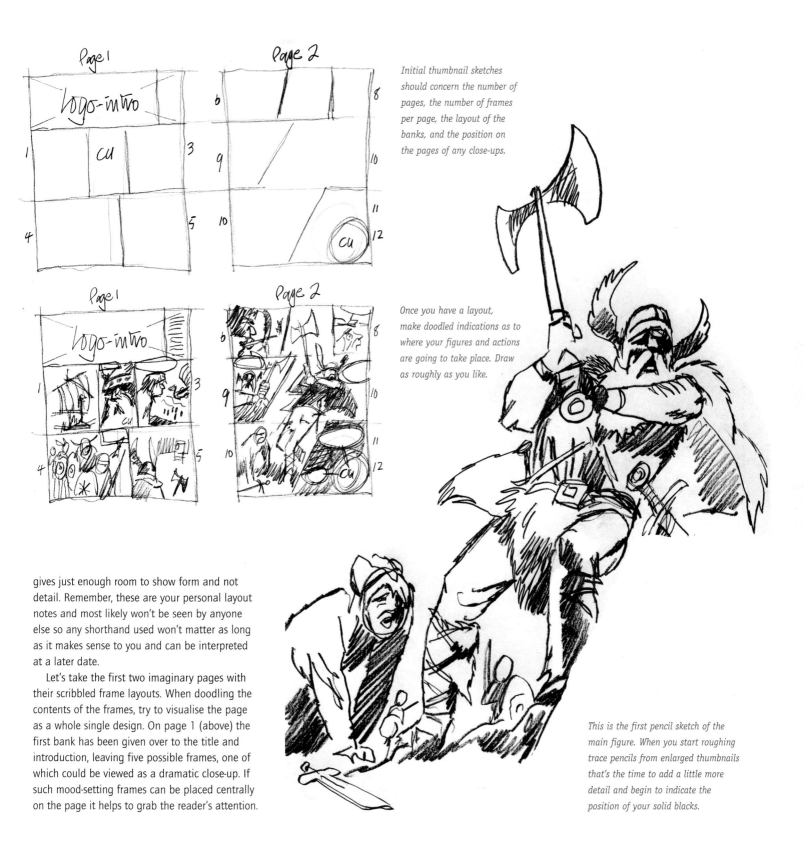

Initial thumbnail sketches should concern the number of pages, the number of frames per page, the layout of the banks, and the position on the pages of any close-ups.

Once you have a layout, make doodled indications as to where your figures and actions are going to take place. Draw as roughly as you like.

gives just enough room to show form and not detail. Remember, these are your personal layout notes and most likely won't be seen by anyone else so any shorthand used won't matter as long as it makes sense to you and can be interpreted at a later date.

Let's take the first two imaginary pages with their scribbled frame layouts. When doodling the contents of the frames, try to visualise the page as a whole single design. On page 1 (above) the first bank has been given over to the title and introduction, leaving five possible frames, one of which could be viewed as a dramatic close-up. If such mood-setting frames can be placed centrally on the page it helps to grab the reader's attention.

This is the first pencil sketch of the main figure. When you start roughing trace pencils from enlarged thumbnails that's the time to add a little more detail and begin to indicate the position of your solid blacks.

The figure was roughly sketched in place and found to be too small. It is a matter of preference which frames you pencil in after the panels have been inked. For me it begins where the reader's eye is expected to alight first.

Here the first pencil drawing has been replaced by a larger version that has been partially inked. The figure slightly overlaps the other frames, adding to the dramatic effect – the axe has been left out for the time being.

The weight or density of the page will depend a great deal on your style or choice of media, and whether you use tone or stipple. Pen work is generally lighter than brush work and makes solid blacks appear crisper.

Page 2 (see page 91) contains a dramatic figure that could be made much of, filling four frames and covering almost half a page. If the two pages together promise action and adventure at this crude stage you're on the right track.

When you are satisfied with your doodled reference sketches, it is time to rule the layout of the pages. If you are confident enough you can ink in the frame outlines and draw within them, but if you tend to alter your content from time to time, it is best left in pencil at this stage.

It makes sense to begin pencilling at the dominant frames where impact is important as this is where improvement and alteration are most likely. The first pencil sketch of the Viking seemed okay at first but I felt that the size could be bigger and that the battle-axe took up a lot of space which could be given over to frames six and eight, and still leave room for speech balloons and panels.

The Viking was redrawn slightly bigger and then partially inked. In the layout, the figure slightly overlaps the other frames and this adds to the dramatic effect; the axe was left out at this point.

Once you are happy with the rest of the pencil sketches, based on the initial layouts, add them to the layout, and give some thought to the placement of solid blacks, not forgetting to leave neutral areas for any text and dialogue.

Mood and lighting effects

When it comes to mood and lighting, there are very few sections of the media that allow as much dramatic licence as cartooning. A cartoonist can throw a headlight beam or a candle glow into a scene with apparent disregard for reality. Glancing light and cast shadows can be portrayed where none should be, and with the utmost effect. A wide range of cartoon characters can suddenly become sinister in the right light.

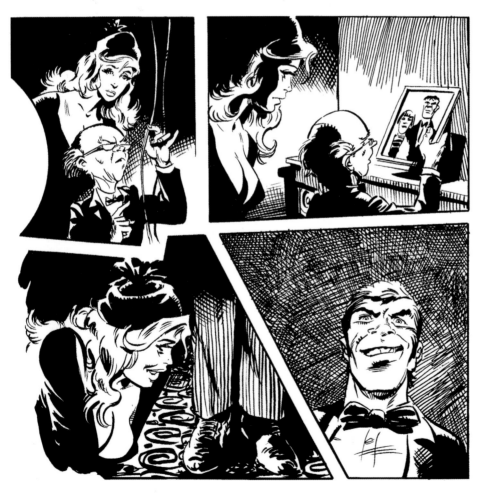

It is possible to obscure most of a face in deep shadow and still preserve character. Paint highlights to contrast with the shadows. Subtle blending can take the edge off the dramatic.

Heavy blacks have been used in these four frames to create atmosphere. They have been over-hatched and appear rather too dark but the addition of text balloons will lighten the page.

As with solid blacks, heavy use of dark colours and cross-hatching can also contribute towards creating an atmosphere or building a specific mood such as an early dawn, a brewing storm, or a dangerous moment. Alternatively, when used on a face it can emphasise a moment of menace or terror.

A solid black shadow, silhouette, or object placed in the foreground will give added depth to an enclosed frame.

When adding shadow to an object or a person the resulting contrast automatically suggests an opposing highlight. This in turn can be exaggerated by removing part of the outline on the bright edge. This works well in an explosion scene or perhaps when someone is caught in the headlights of an oncoming car, and in any situation where the lighting is extreme rather than just bright

The technique is equally effective when used with colour, especially with colours that advance and recede when laid in subtle shades and tones adjacent to each other – these are complementary or opposite colours. If you stare at a bright red object and then close your eyes you will see the outline of that object in the back of your eye, preserved for a moment in its complementary colour, green. Indigo complements orange and violet complements yellow; green also complements magenta (which is not a true primary colour but a mix of red and violet).

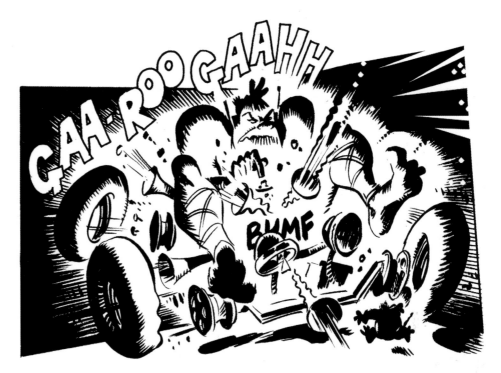

Dropping lines out gives a high-lit, explosive effect.

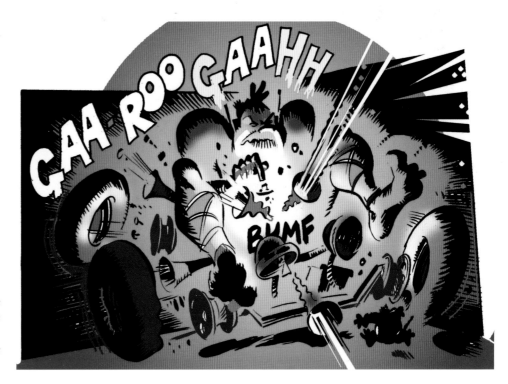

By using colour gradation it is possible to refine the centre of the explosion without obscuring the line work. In this case, subtle blending works and gives an explosive effect.

Conveying movement

To give the illusion of movement to a static drawing requires that the action must first be 'frozen' convincingly, and then made to move by adding subtle 'whizz, zip, and splash' lines that are familiar to comic readers world-wide. The difference between a hand hesitantly reaching out and the same hand recoiling is just a matter of a few added or subtracted brush strokes.

Grotesque cartoons are so unnatural in appearance that any old 'zip' lines will convey movement. With realistic drawing more care should be taken to get the proportions correct and the posture, if not 100 per cent accurate, should at least look believable. One sure way of activating a figure is to leave a space between it and its cast shadow. If a figure is off the ground the mind is convinced that it's going somewhere. A slight list to one side or a stoop forward will give the figure direction.

With lampoon figures the same things apply but the posture can be anything from ground-huggingly low to bolt upright. It is the manic speed lines that count here. Legs don't run, they 'windmill', arms don't swing, they flail. Mouth agape and eyes akimbo, the lampoon character hurtles and bounces from frame to frame and we know that it doesn't really hurt. The difference is that when the realistic figure hits the ground and you've got the drawing right, the reader should wince.

If you have a figure moving forward, try to keep all speed lines behind it, as even the smallest 'twitchy zip' line drawn in front will kill the apparent momentum. Lines drawn to indicate a speeding character are given a kind of softness by being slightly less than straight (achieved by the use of French curves). Speeding inanimate objects – cars, rockets, and custard pies – can be propelled by curved lines but will reach a far higher velocity on the end of a set of ruled straight speed lines. When a particularly fluid motion is required a brush gives a very spontaneous and pleasing speed line.

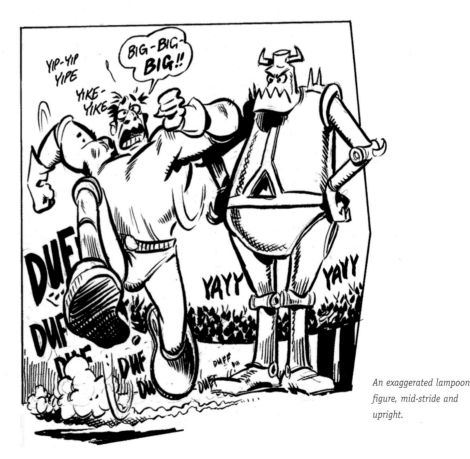

An exaggerated lampoon figure, mid-stride and upright.

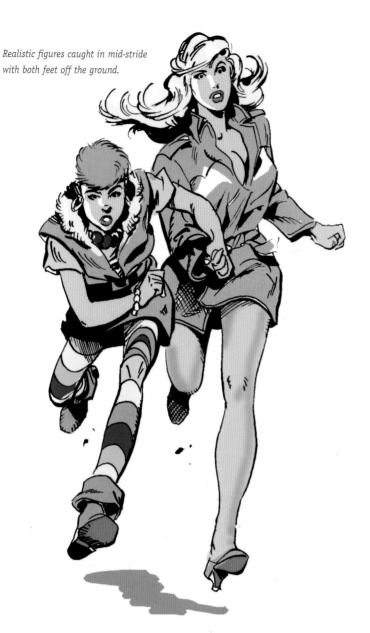

Realistic figures caught in mid-stride with both feet off the ground.

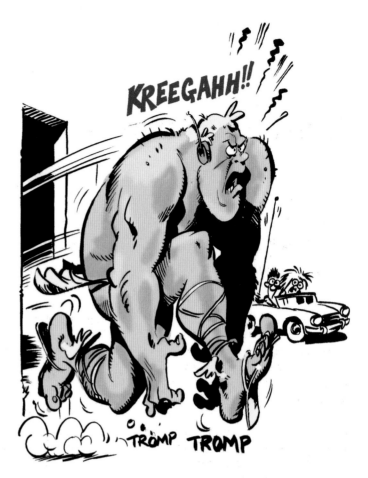

This galloping lampoon figure also has both feet off the ground and speed lines behind him.

Another way to indicate motion is the directional sound 'FX'. This is lettering built into a speed line, curve or zip line. This character has had something 'zooooomm' past that has knocked her for a loop, as indicated by the single but very effective 'looping' speed line. As it stands she has apparently been blown over, but the addition of a small star or 'Thump FX' in the top left corner of the frame would change the perception completely.

Storyboarding

Storyboards link the gap between theory (a script) and practice (an act) by putting the words into visual form. In this way the concept can be received and understood in the same way by diverse people, who otherwise might form differing ideas from the script. In other words, the storyboard is a visual common ground to launch an idea from, and as such lays a burden of responsibility, not to mention patience, upon the artist.

Telling a story by storyboard differs slightly from thumbnailing because the end result is usually animated or used as the plan for a film. A loose script is prepared for a movie or TV advertisement and the cartoonist/illustrator uses his or her imagination to draw a series of sequential semi-finished sketches depicting the action.

These sketches, and there may be hundreds of them, are all the same size, in proportion to a cinema or TV screen and pinned to a wall or board (hence the term 'storyboard') as a guide for producers, camera crew and actors. The process is ongoing and the artwork is continually under discussion and subject to sub-division and change until the storyline has been hammered out to everyone's satisfaction. The quality of the artwork is not as important as the content, which in turn need only depict the action. Most storyboard illustrators favour either a felt-tipped pen or a brush for speed, and quality will depend mainly upon the time allowed and the number of boards required. There is usually little time for colour unless the script specifically requires it. The smallest storyboards may consist of as little as three sketches, which show backgrounds and positions, while boards for a major film can run into many hundreds.

The storyboard artwork need only be detailed enough to depict the action sequences of the film.

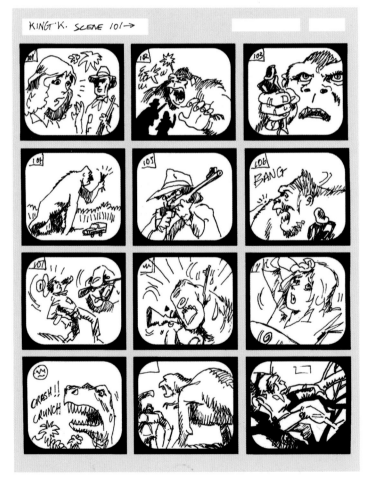

Some examples of brushwork storyboard illustrations.

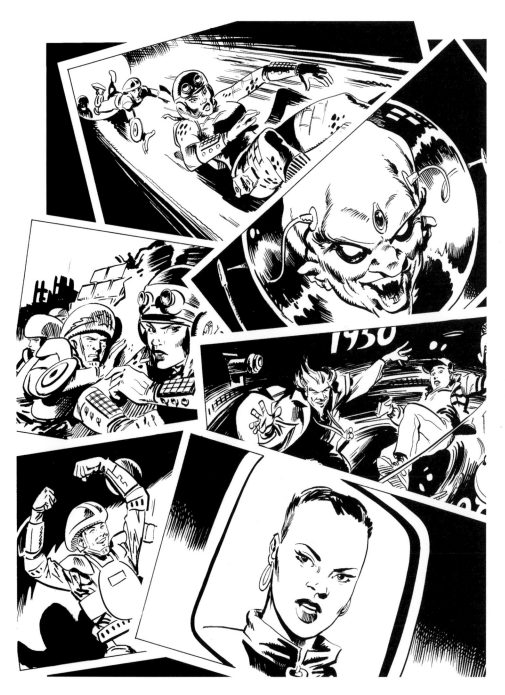

Use of text

Text balloons and panels should always be applied sparingly when depicting such things as storyline (narration) or 'signpost panels', and the character dialogue kept to a reasonable, unobtrusive level. Except, of course, when there are moments of tension that can be emphasised by the use of bold or italic, or bold italic, text. Further enhancement can be achieved by including unusually shaped signpost panels and text frames.

Panels and captions should be noticeable but not too intrusive or bizarre.

A long piece of text or narrative may deserve a frame of its own, perhaps with its own border theme like the scroll used here.

Airbrushing effects

One of the most time-consuming yet rewarding tasks in cartooning and illustrating is that of turning a flat black-and-white drawing into a 'three-dimensional' colour image with an airbrush. Especially so when the airbrushing is carried out in the digital world, where there are no fumes, no smudges, no tacky masking tape, and no washing up.

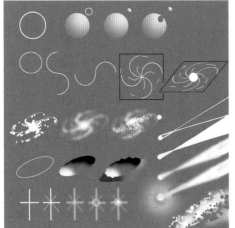

Once you have created the various elements of the composition, scan them into your computer.

To prepare your drawing for colour, first select a black line, then 'select similar' so that all of the black lines are selected. 'Cut' and 'paste' to create a new layer in Photoshop containing only the black lines. Now you can add colour and effects in the background layer without losing the clear black lines of your drawing in the new layer.

To create an airbrushed effect, select the area or areas of the image you want to work on, for example, the spaceship windows, and fill with a flat, medium-toned colour. Then apply paint with the airbrush tool at a pressure of 20–30. Use darker tones first and then lighter ones. It can be difficult to re-select an area, so make sure you do not lose the selection until you have finished working on the area.

Another way to 'airbrush' a selected area is to use one of the gradient tools to apply a smooth transition between different colours, either in a circular or linear direction.

The stars and planets, comprising basic circles and ovals in white on a medium-toned background, were created by using the 'marquee' tool in Photoshop. They were manipulated into galactic shapes, which were then either airbrushed, as in these sequences, or selected and treated with the 'gaussian blur' tool. They are part of a library of stock files, for example, trees, buildings, skies, stars and snowscapes that I keep for general use.

The space ships were drawn with a technical pen using French curves to achieve the outline. They were then coloured using the technique described above. For simplicity and speed they were done separately and dropped into the cosmoscape background.

This was a one-off cartoon strip that was inked on art board, scanned into a Mac G4 and airbrushed the safe way – digitally!

I spent some time doodling, then made a pencil rough of the alien's head, which was then inked and scanned into Photoshop before it was coloured.

The skin was given a flat medium green tone with highlights and shadow being brushed on over the same period of selection (it is difficult to reselect a multi-toned area once it has been deselected) followed by dots of airbrush and dimples for texture. The helmet was then selected, flat tinted Mediterranean yellow, then tinted with orange, and finally highlighted with white. It was then sized to fit the strip, dropped into place and a fine white line stroked around it before the image was flattened.

Masterclasses

Humorous posters

Lichtenstein-style

Lichtenstein style does not lend itself to visual humour, so I relished the opportunity to produce a wacky 'catch-phrase' style of humour while allowing the colourful subject matter of the posters to catch the eye. The chosen process left plenty of time to consider what text, if any, could be added to spice up the design. A common denominator, apart from the art-style, was needed to tie the posters into a series and I decided to use a 'True Brit' adventurous character named Ralph.

In this exercise, I have focused on the first poster in the series, entitled 'Suddenly ...'

The American, Roy Lichtenstein (1923–97) was a leading 'pop art' artist of the 1950s and 1960s who first found public acclaim by taking a frame from a comic book that showed a fighter plane blowing up an enemy aircraft, and enlarging it as an oil painting, complete with Benday (half-tone) dots and explosive lettered sound effects. Although best known for this, Lichtenstein also adapted the same exaggerated line and dot format in abstract paintings and murals.

Tools used

HB pencil
Technical pen .05
No.1 Sable brush
Black drawing ink
Layout pad
Lightbox
Computer: Mac G5 OS 8.5
Software Photoshop 5.5

2 | An initial thumbnail pencil sketch was made by using an HB pencil to trace very roughly over the chosen photograph on a light box. This sketch was made in order to add and position some wings on the fuselage. The wings looked alright but the bulky exhaust manifolds looked out of place and I decided to leave them off. Rulers and curves were sacrificed at this stage for the sake of speed.

1 | An old model of a World War II aeroplane was the basic inspiration for the poster, having been discovered wingless and dusty in the depths of the garage. The SE5a fighter plane struck me as being an essentially 'True Brit' machine and a perfect subject around which to build a 'Ralph' poster, so out came the trusty digital camera and a few profile snaps were taken of the model's carcass. Good references can add a great deal of validity to a cartoon and this old model was sufficiently detailed and proportionately accurate enough for the job. No doubt about it, this was going to be Ralph's kite. The fourth snapshot was chosen as a base for the design.

3 | The pencil rough was scanned into the computer, re-sized to roughly 21 x 30cm (8 x 11½in), A4 landscape and printed out for use as a tracing guide. The resulting printout was strong enough to form the basis of an inkline drawing, done with a technical pen and ruler. I decided that I would keep this small and much neater ink drawing for possible re-use at some future date, never a bad thing to bear in mind when preparing intermediate drawings.

4 | I scanned the ink drawing into Photoshop, where it was used to choose the solid black areas and relevant colours. I rotated it in order to choose the diving angle of the aircraft (about 36 degrees anti-clockwise). The colours used – olive green aircraft with complementary red wheels, red, white and blue roundels, all set against a pale blue sky – were set by the subject matter. This only left the choice of colour for the lettering. I considered purple but rejected this in favour of a bright yellow. Quick test colour swapping was carried out in Photoshop by pouring one colour over another via the 'paint pot' tool. Although this tends to erode the black line and is not advised for finished colour work, it is acceptable for experimental exercises such as this. Unwanted colours should really be removed by use of 'undo' under 'edit' before a new colour is poured.

TIP

It is always worthwhile taking the time to (low-tack) tape your trace sketch to the light box and your art paper to the sketch. Rigidity is the rule.

If the finished poster was to show the full aircraft the scale would allow no room for a recognisable Ralph in the cockpit, so a crop was needed. The A4 proportional crop was achieved in Photoshop and then enlarged to poster size, roughly 30 x 42cm (11 x 14½in), A3 portrait and printed out. Using a lightbox, technical pen and No.1 sable brush, a basic inkline drawing was traced from the printout. If you don't have a lightbox a lightweight tracing paper will suffice, although care must be taken when scanning from tracing paper. You should run two scans, one as grey and one as black and white, and experiment to find which converts to line best. The drawing process involved very little freehand work and was almost entirely a job for the technical pen, ruler, French curve and ellipses template.

5

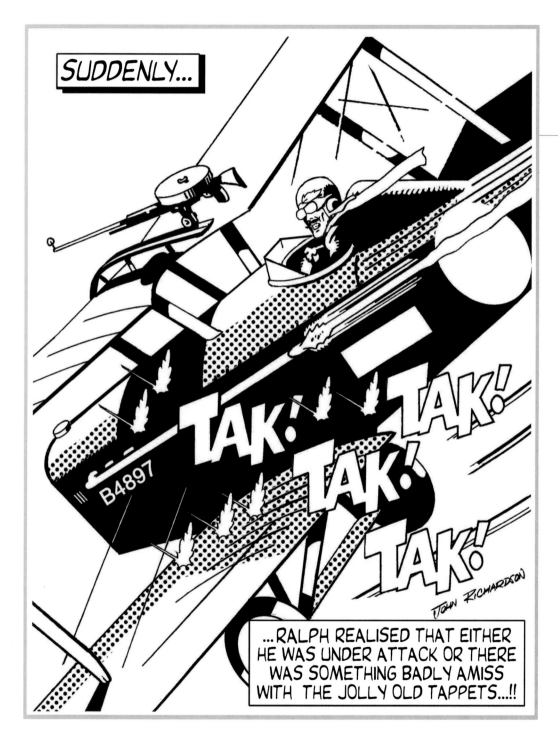

6 | At this stage such invented detail as the gun, the roundels, fuselage decoration, 'TAK! TAK!' sound effects, wing wires and whizz-lines, black dots and Ralph were added to the drawing, which was then scanned into Photoshop as the finished black line art.

TIP

Save your work repeatedly during this process. Better save than sorry.

7 | *The CMYK mode was chosen and the design was coloured using the small colour sketch as a guide and the 'paint bucket' tool to apply the colour. One 'TAK!' was drawn and cloned around the drawing, as was the 'bullet strike' effect. The dots were added by duplicating the drawing and colouring the area of the copy to be dotted with a medium grey. The shade of grey is important as it dictates the actual size of the individual dots. For instance, at 20 half-tone dots per inch, a dark grey will convert to 20 large dots, while a light grey shade will convert to 20 smaller dots. This grey area was then selected using the 'magic wand' tool to select an initial small grey portion and the 'similar' command from under 'select' in the bar menu was used to grab the rest. This ensures that every bit of your grey area is selected. The selection is then inverted and the rest of the drawing cleared to white, leaving just the grey areas to be converted to dots. (If you have used grey as part of your colour scheme you will have to select your dotted area by use of the 'wand' tool and the shift key and fill this area with your chosen shade of grey after clearing the rest of the artwork.)*

8 | *The mode was changed to greyscale and then converted to bitmap, choosing the half-tone screen option. The output was set to 300 dots per inch, and the required frequency, angle and shape of the dots selected.*

9 | *The mode was changed under 'image' back to CMYK and the black dots were selected by first selecting the white area and then inverting the selection to grab the black dots. (At this point, if coloured dots were required, the 'fill' command could be used to colour the dots.) The dots were then dragged back to the original drawing as a new layer. After lining the dots up to match the drawing beneath they can be fixed in place by using the 'flatten image' option in the layers palette. Repeating the process can allow different sizes and colours of dots to be applied to different areas of the drawing.*

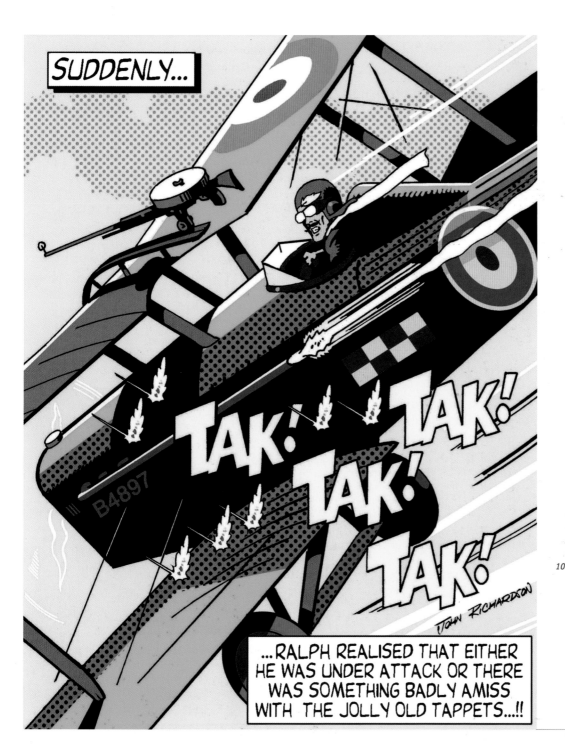

10 *Right from the start of this project various scenarios and punch lines were considered as the artwork progressed. The text was decided upon and placed on the artwork at the finished line stage, then the image was flattened. In hindsight, it would have been better to have kept the text on a second layer where later changes could be easily applied without altering the finished artwork.*

Children's books

Glorp

There is no more rewarding part of cartooning than children's book illustration. The variety of subject material is vast and the freedom of style used by illustrators in this section of publishing is most satisfying. I have to add that this is also one of the most fiercely competitive sections of illustrating to be found. My brief here was to create a set of colour illustrations for the children's book *Glorp*.

Glorp is an experimental SAS-fighting robot that has been wrongly programmed as a 'mess' cook. This clashes with his warrior circuits, causing him to inflict alarm and chaos on those around him. As the illustrations were aimed at children, the drawings needed to be colourful, interesting and, above all, dynamic.

In the illustration featured, Glorp has been sent on a food foraging expedition. However, he has not yet perfected his motorcycle skills – he misses the brakes and crashes into a barn.

There are simpler ways than the ones used here to colour a black and white drawing, especially on a computer, but they're much less fun.

Tools used:

HB pencil
Technical pen .05
Technical drawing ink
Layout pad
Lightbox
Computer: iMac G5 OS 10.4.3
Software: Photoshop CS2 9.0

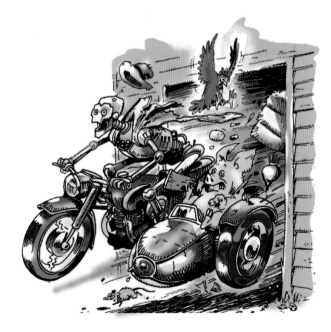

TIP

If you are working on a computer, create a couple of desktop folders named 'Bits' and '2 B Binned'. In order to cleanse your files of unwanted and/or duplicated material, put all such material in the Bits folder and at regular intervals cautiously transfer those items that seem to be abandoned into the 2 B Binned folder. At even longer intervals dump these items in the real bin.

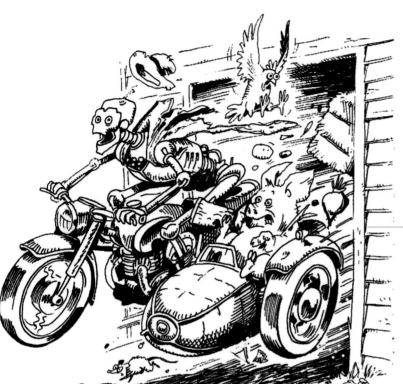

1 | *I started in the usual way by doing a number of very small pencil thumbnail sketches that could be amended, altered or binned without much loss or hassle. Once they showed a semblance of what was needed they were scanned into Photoshop and enlarged to a comfortable working size (A4) and saved as trace roughs. Then the first one was printed out and taped to the lightbox and a wire-line black ink drawing made over it on better quality paper (130 gsm). This drawing was scanned into the iMac and I named the file 'original' and sized the image.*

A duplicate was created, named 'colour' and the CMYK mode selected. A portion of the black line was selected using the 'wand' tool and the rest selected using the 'select and similar' command, all of the black line on the duplicate copy was coloured a pale blue (any very pastel shade will do) using the 'paint pot' tool and the 'fill' command, and both files safely saved. | 2

Still in Photoshop, using the 'paint pot' and 'airbrush' tools the drawing was coloured very roughly, even crudely. At this stage I tried a slight 'gaussian blur' filter (there goes the thin blue line!). There's no need to stay rigidly within the blue line as this looseness gives an added charm to the finished drawing.

3

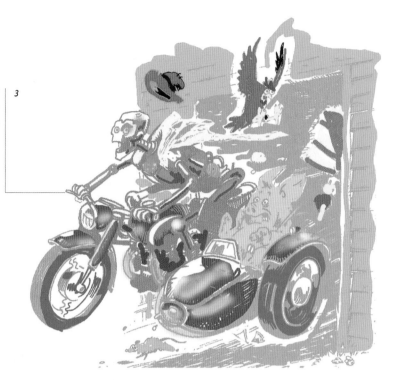

4 | *Highlights and shades can now be added where required, using the 'airbrush' tool set on normal, at a pressure of 25. Unless a more simple flat colour effect is preferred, in which case deliberate 'carelessness' with the airbrush tool is to be encouraged. Exactly how careless you should be is a matter of personal taste and can be rectified later if too obvious. When satisfied with the applied colour any layers that might have been created can be flattened using the 'flatten image' command in the layers palette.*

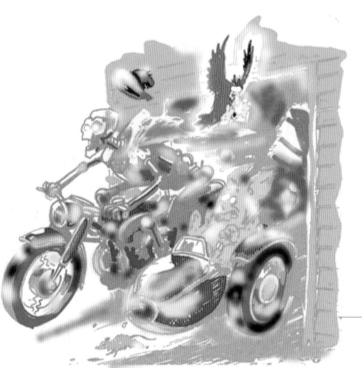

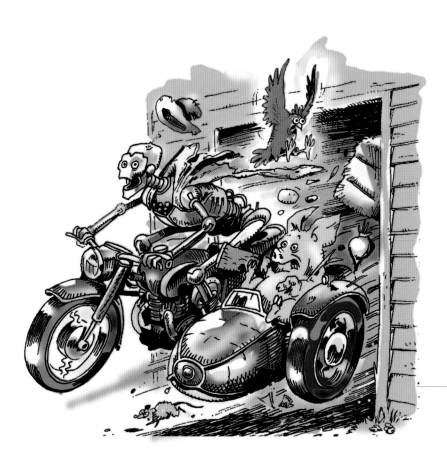

5 | Next I opened the first black line drawing which was saved and named 'original' and selected the black line using the 'wand' tool and the 'select/similar' commands. I then transferred it to the colour drawing by drag and drop use of the mouse and the 'move' tool and carefully aligned both drawings to cover up any sign of the now much depleted blue line (that's why it was put there in the first place). The layers are then flattened and you can now see the serendipitous effect all that 'careless' colour application has had. Further effects can be obtained by choosing which bit of 'overspill' colour gives offence, selecting that colour using the 'pipette' tool and 'touching off' the excess overspill with the 'paint pot' using the same colour, black or white. The result should be a vibrant and colourful illustration with kid-appeal.

Another drawing in the set, showing our 'herobot' mastering his motorbike and sidecar just before he hits the barn. | 6

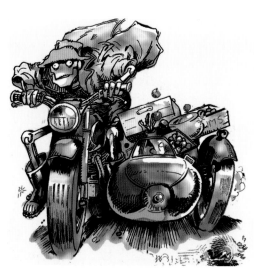

Greeting cards

Home-made greeting cards used to be 'one-off' originals, that is before the advent of the computer. Now your design can be coloured and lettered digitally and printed for friends, family or charities. Although it might seem like a costly exercise, what with high quality paper, printer inks and fitting envelopes, compared to the cost of shop-bought cards, the idea seems brighter by the minute.

Multiply your design ambitions by the number of greeting card occasions that there are – Christmas, Easter, birthdays, Mother's and Father's Day, Valentine's Day – and what began as a hobby could become a full-time job.

Always remember that if you want to print your card, the shape of your design and the finished size are vitally important. It is advisable to choose a standard ISO size format, such as A4 or A5 and then there should be no trouble acquiring the correct size envelopes – ISO C series, C4 or C5. You could consider folding an A4 sized print in half down its length, not necessarily down the centre, for an unusual effect, although you will then have to design the envelope too. The bonus to all this is that out of the hundreds of cards you design, eventually there just might be a couple that are worth publishing.

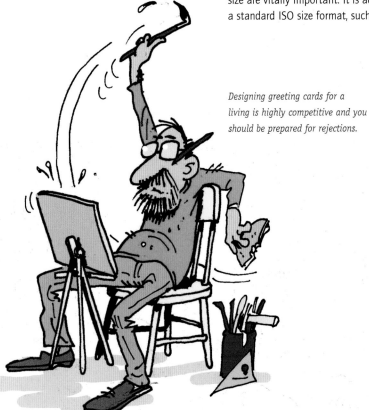

Designing greeting cards for a living is highly competitive and you should be prepared for rejections.

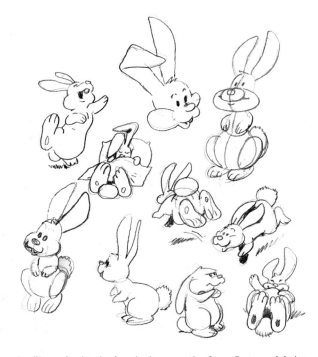

Doodling and animating bunnies in preparation for an Easter card design. It helps to visualise the object – its shape, posture and facial expressions.

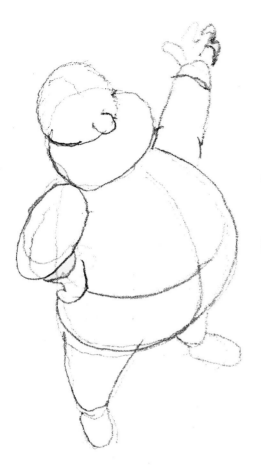

Initial rough pencil drawings of Father Christmas – capturing rotundity. Once the basic shape is drawn you can start filling in the details.

After drawing this Father Christmas, it was scanned into the computer and coloured.

Note how the differing styles, woodcut (left) and wire-line (right) below, suggest the different feelings of tradition and modernity, cosy and commercial.

This Father Christmas was created for a page of gift labels that were laid out in Photoshop.

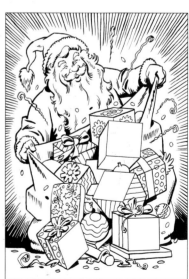

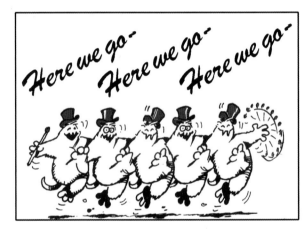

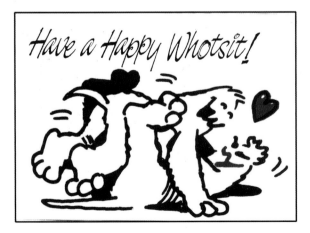

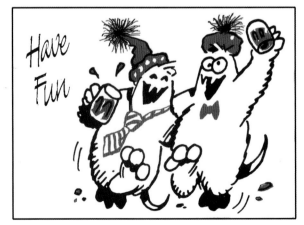

The Grumlins were originally devised as 'fillers' for cartoon strips. However, I decided that they had potential as characters in their own right and so I used them in a set of twelve greeting cards, six of which are shown here. Because they were designed for an abstract purpose they were easily adapted for birthdays, Valentine's day and for other occasions.

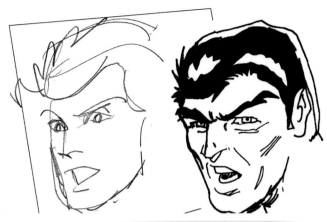

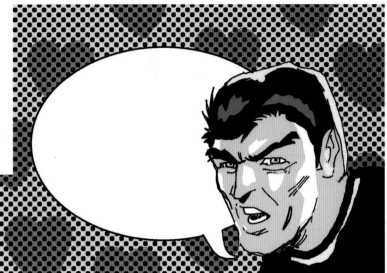

This card and the one below were designed for personal use and were created in the usual way (doodle, pencil drawing, inked drawing and computer coloured). From a bunch of doodles two faces stood out enough to develop and take further as card designs.

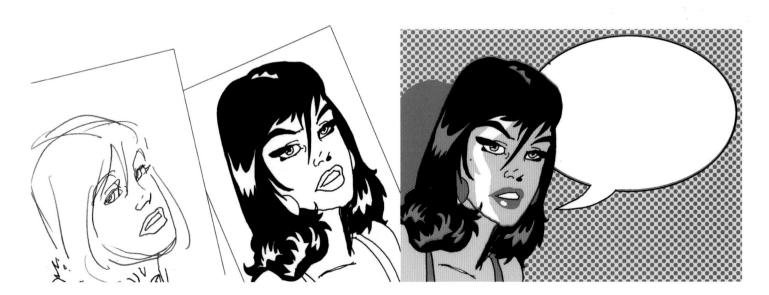

I deliberately left the face of the woman bland so that any kind of message could be added via alphabet transfers or the computer. These designs now await further development or refinement to see if they have any commercial potential.

Editorial illustration

Dame Edna

For the book *My Gorgeous Life* by Barry Humphries, I was asked to provide illustrations in a pen/brush style. The images needed to resemble 1940s comic annuals and have an adventurous, period feel about them. The job was to be in black line and details such as the schoolgirl's gym slip, Australian architecture and foliage had to be correct.

The book was written a few chapters at a time, which made illustrating it not only interesting, but also left me in suspense as I couldn't wait to find out what happened next.

I began with a study of the first available chapters of the book and a few doodles to start the process. From these a set of scenarios and character studies were pencilled for approval and comment. This gave the client the opportunity to provide reference and advice regarding venue and costume so that a set of three detailed pencil roughs of the first illustrations could be prepared and sent to the designer. Eventually, they arrived at three layouts containing all the required details

and story lines, which were then drawn and inked. With the size, style and basic references agreed it became a matter of waiting for the next few chapters to arrive and to repeat the process until the job was completed.

The initial doodles were sifted through and three were selected. The rough pencil sketches were done with a 2B pencil on layout paper at roughly A4 size so that they would easily fax to the designer. Once approved, they were then traced via a lightbox onto CS10 paper and inked with a No.1 sable using a hatch and cross-hatch style that was popular in children's annuals around 1935–45.

1 | *Visualising the Dame as a child through to a mature adult took some doing.*

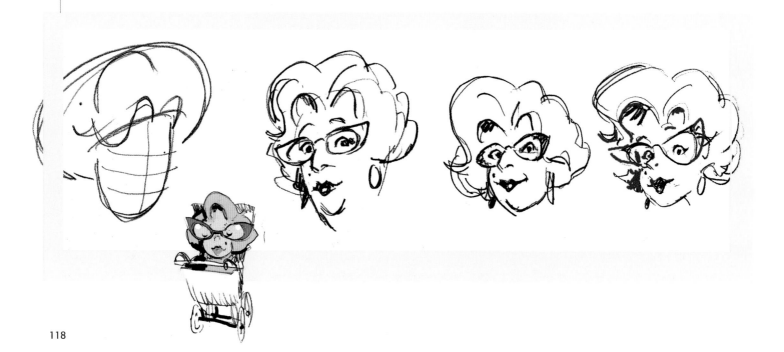

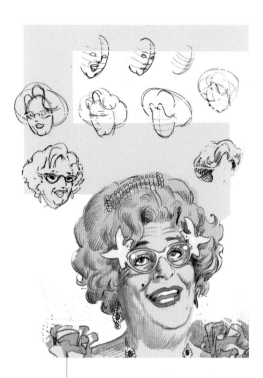

2 An oval for the head, topped by a
'doughnut' for a hair style, add a giant
quiff and a pair of superspecs and then
refer to the reference photos for details.

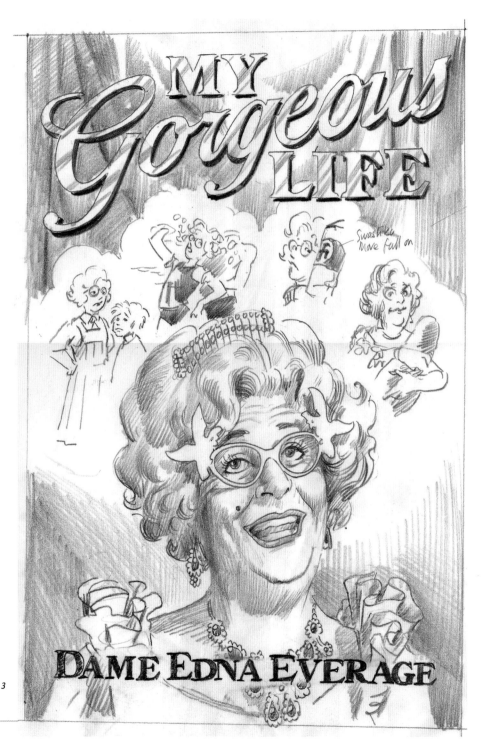

A pencil rough for the cover of the book. | 3
Sadly, it bit the dust and the photographic
version was chosen instead.

4 | There were about three roughs drawn and amended for each finished illustration. Barry Humphries included lots of detail in his illustration briefings so it was really a matter of where to draw things rather than what to draw, which made life that little bit easier. The figure of the bright young Edna was first doodled, then the selected doodle was pencilled at full size.

5 | To show the sunlight streaming through the window, a secondary sketch plotting the light and shade was made.

6 | Using the pencils on a lightbox, a final trace was made while simultaneously planning what hatchings were going to be made, which lines were to be tight, which left loose and all the little additional details that would only be brought out by the inking process. The tools used were the No. 1 sable, an old squirrel-hair used for solid black application, and the trusty 303 pen.

Four of the finished drawings showing Edna through the ages – from her teenage years at school during World War II to her adult life at home. Once I had established Edna's various guises, I concentrated on adding the all important background detail.

7

'What's your name, kid?'

Strong arms were around me ...

The circle of evil faces peered questioningly at me.

My new friend popped her pretty little head through the kitchen door.

Caricatures

Val, Colin and friends

With caricature the aim is to produce a recognisable portrait of a person that pokes fun in a gently humorous, inoffensive way. The trick is to pick out the essential features and proportions that identify the individual and simplify and exaggerate them slightly. Clothing and incidental details can also be used to comment on the subject's lifestyle and interests. Care needs to be taken when compiling information for any humour content. The safest way is to work from good reference, which is why the following caricatures were created from photographs.

Tools used

HB pencil
Technical pen
No. 01 sable brush
Drawing inks
Layout pad
Lightbox
Computer: G4 power Mac OS 8
Software: Photoshop 5.5

When you are planning a caricature, before putting pen to paper it is advisable to gather some information on your subject.

The characters featured here, Val and Colin, recently sold their interest in a private club and decided to go off on a well-earned cruising holiday. The framed caricature was planned as part of their send-off. The club was called Val's Priory Club and it was decided that upon leaving, Val would have to get her priorities right (no pun intended); consequently, Val was drawn with a bag of 'priorities'. Among the hobbies she intended to pursue were cross-stitching and computing, both of which are depicted in her shoulder bag. The new car bears the number plate VPC 1

(Val's Priory Club 1) and the couple's cruising holiday was marked with streamers, champagne and a suitcase.

As for Colin, he is a big-time supporter of the club's pool team, hence the smattering of pool balls around his feet. In addition, his horse-racing bets have given quite a few bookmakers a limp, so he carries the *Form* under his arm. Further reference to his interest in horse-racing is the unhorsed 'favourite' in the background. Last but not least, Colin sports a 'trade-mark' pony tail that is a bit awkward to draw as it lives on the back of his head and we need to show the front. But it is so much a part of his 'larger than life' character that it cannot be left out of the drawing.

TIP

There are times when someone will ask you to do a caricature: 'that's him, that little pink smudge in the back row of the school photograph, 23rd from the end... mind you, he's nearly 36 now but he hasn't changed much'. It's sometimes better to refuse to work from a bad reference photograph than to persevere with a caricature that looks just like the blur on the photo but nothing like the person.

There are two main types of caricature: realistic and exaggerated styles. What is accepted as a great, if exaggerated, likeness by the one who commissioned the drawing might be seen as the basis for a law suit by others. Very few photographs are taken with a future caricature in mind and this photograph of Val and Colin was no exception. However, it did the job well enough, especially as I knew the characters personally and only needed a few photographic guidelines in order to achieve a likeness.

1

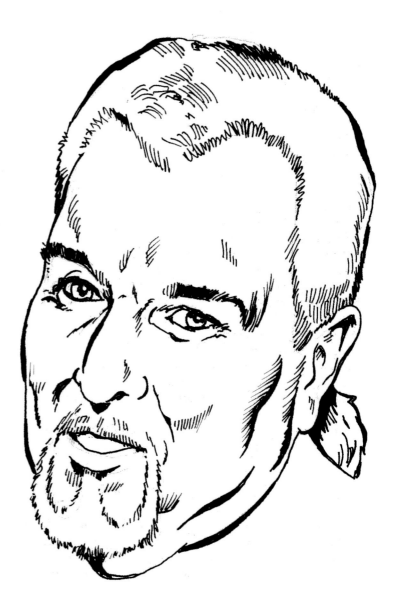

2 The reference photograph, by this time reduced to greyscale, was printed out at just less than A4 size and attached to the light box, where a light pencil trace was taken on smooth-surface 130gsm (60lb) cartridge paper. This stock is ideal if the final drawing is to be an original ink or colour sketch but a much thinner layout paper can be used if the end result is to be a digital print, as here. The lightly pencilled rough was inked over with a fine pen nib or technical pen, using the original photograph as a reference for the fine detail adjustments. I cleansed the drawing of pencil marks with a soft eraser and scanned it into Photoshop, and immediately saved it as a greyscale file – even in its raw state it's better to have it on file than having to start again in the event of a computer crash.

3 | *The bodies and background detail were then sketched separately, leaving room for the later addition of the heads. At this point, cleanse the drawing of 'scanner dust' and any penned errors using the pencil and eraser tools and convert to CMYK (Cyan, Magenta, Yellow, Keyline black, for printing) or RGB (Red, Green, Blue, for internet or video viewing) under Image> Mode> CMYK or RGB. Apply colour by using the brushes from the Tools palette – this will vary according to your taste and style. In this case the heads were selected and temporarily positioned onto their respective bodies to check for a good fit. Working on the heads once again, the face, eyes and hair were flooded with flat colour using the 'paint pot' tool.*

4 | *All the areas of flesh were selected using the wand tool, and a flat, medium-toned flesh colour was laid down. Keep the area selected until you're sure you've finished as partially graded areas are very difficult to reselect once flattened.*

5 | *A darker shade of the same base colour was selected and the shaded areas were then filled in with the airbrush tool.*

6 | *Finally, a light tint was lifted from the original flesh colour and the highlights were added. The last few were added in white.*

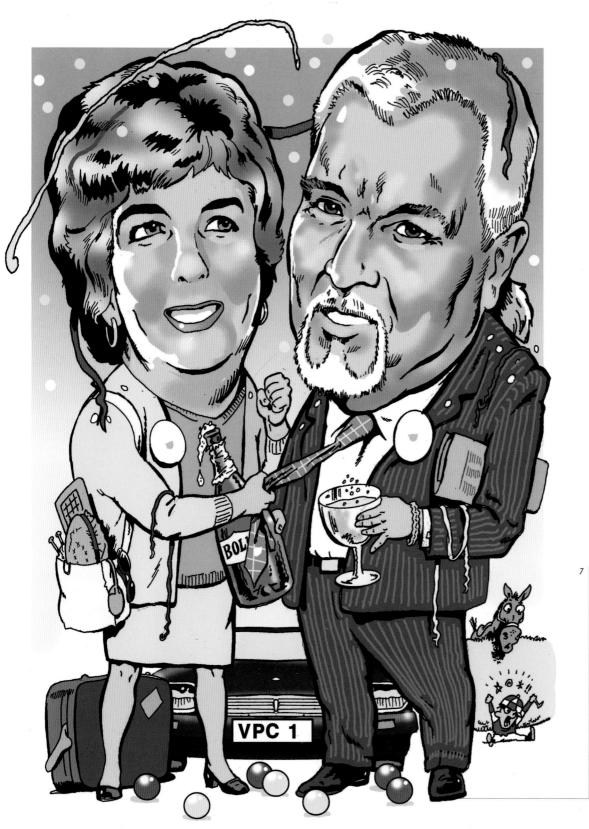

7 | The bodies and background details were then coloured using the same process as for the heads (the top half behind the heads was left until last). The coloured heads were selected and dropped over the previously fitted black and white line versions and the whole flattened to form a single image. The last job was to choose a colour for the background that didn't clash with everything and then the job was saved and printed on heavy gloss photo paper (to prevent fade as much as possible).

Capturing likenesses

The caricatures on these pages were done in the same way as on pages 122–25. However, there are pitfalls to watch out for when your subject is a baby. Babies have had no time to evolve character in their faces; only innocence and cuteness are apparent. Don't ever attempt to add character to an infant by exaggerating its button nose, rosy cheeks or any other features as this is guaranteed instantly to alienate the mother.

1 | *Sophie was in a thoughtful mood when the photograph was taken so the smile and dimples had to be added at the inking stage. Babies don't look too good with heavy outlines so the inking was done sparingly with a technical pen and only the left and lower side of her face given any weight of line. The rest of the face was naturally outlined by her hair. The eyes were next, and I decided to arch the lower lids upwards slightly and form a tiny crow's foot. I wanted to show Sophie gurgling so allowed her mouth turn up a touch at the corners. Her rosy cheeks were begging for dimples so I inked them in to mark the spot and then highlighted slightly at the colouring stage. The pale flesh colour was applied flat with selected shades of the same tint added, often overlaid with highlights in a random sequence, until the desired skin surface was achieved. The subtle rosy cheek colour was brought in during this trial-and-error stage and a tiny tinge of 'rose' on the chin balanced the whole effort. Sophie was underlit slightly by the light reflecting off her white bib and this cast a corresponding shadow above her nose. I thought this made her button nose look even better and not only left it in the picture but emphasised it.*

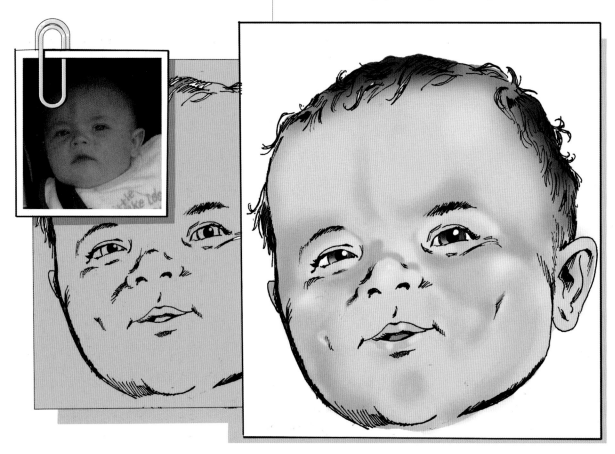

126

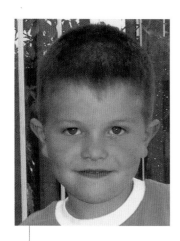

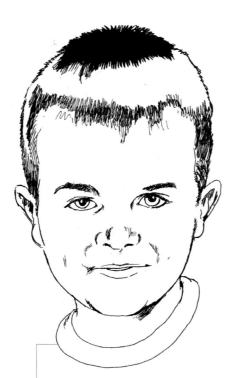

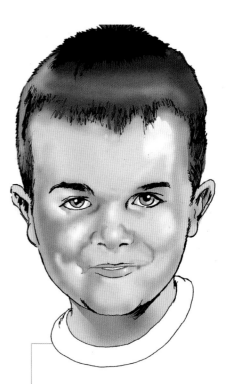

2 | Thomas has just reached that age when a hint of mischief creeps into his angelic expression. His eyes hold a sparkle that deserves to be recorded. To do this, I made the pupils slightly bigger than in the photograph and dropped a white dot on the edge as a highlight.

3 | I gave very little weight to the line-work before the colour was applied in the same way as in the previous examples. The initial base flesh colour was airbrushed into the hairline to soften the overall look of the face.

4 | As no outline was used to show young Thomas's features, they had to be picked out in light and shade. The shade was airbrushed on first, then a lighter colour was added to establish the features. The process was repeated until the definition was apparent and a balance had been struck.

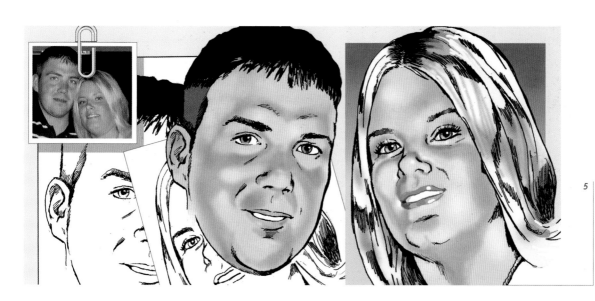

5 | Dave has enough visual character to pick out his likeness without much of a problem. However, I was never going to do justice to Tracey with a simple pen-and-ink sketch. I felt that her likeness deserved oils.

Orla

This caricature was a little different to the one of Val and Colin (see pages 122–25) as I was given a specific request to show Orla in a fairy costume.

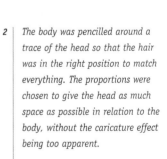

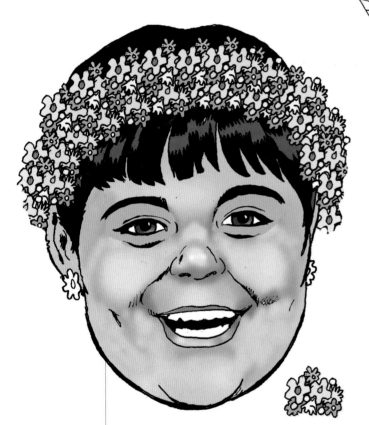

1 | Orla was drawn the same way as previously but the outline of her face was allowed to stay heavy as it was to be dropped into a background of dark hair on the body drawing. A small posy of flowers was added to one corner of the drawing. A loop was drawn round this with the 'Lasso' tool and tightened by clicking within the loop with the Alt+Wand tool. The art was then dragged to Orla's forehead where the Alt+Move tool was used to make multiple copies to form a head band.

2 | The body was pencilled around a trace of the head so that the hair was in the right position to match everything. The proportions were chosen to give the head as much space as possible in relation to the body, without the caricature effect being too apparent.

If you use cloned items like stars, sparkles, snowflakes, flowers and leaves, and they work, open up a file and store them for future use.

3 | *After colouring the body, a 75 per cent opaque layer was added over the wings and flooded with white to give a faded pastel gossamer effect. The fairy wand was tipped by a blast from the airbrush tool, and a few sparkly stars cloned around the figure. Then the head was positioned on the body. The drawing was then flattened and printed.*

Hoarding art

Metropolis

Outdoor scenes are usually very involved and require a great deal of detail. From the interesting silhouette of a whole building on the horizon down to the keyholes in doors – where do you stop? One popular outdoor scene is the cityscape, where sheer drops and exaggerated perspectives combine to set parameters for detail and also challenge the cartoonist. This exercise will show you how to draw a bat's eye view of a city.

Tools

HB pencil
Technical pen
Ruler
Ellipses template
Lightbox
Computer: G4 power Mac OS 8
Software: Photoshop 5.5

Flying cinema seat

The full brief was to provide a 48-sheet hoarding (12 x 60 x 40in joined sheets making a final size of 120 x 240in/3,048mm x 6,095mm), black-and-white poster for a cinematic museum that had a system based upon superwide film. This type of film gives amazing detail when projected on to wrap-around screens, which in turn gives the audience the illusion of 'being there', a part of the action, hence the young lady in the flying cinema seat. However, for the purpose of this exercise we will concentrate on the development of a portion of the cityscape and then apply some 'mood' colour. Despite the need for great detail on the finished artwork, the original A3 illustration began with just a few postcard-sized doodles to determine the aerial point of view.

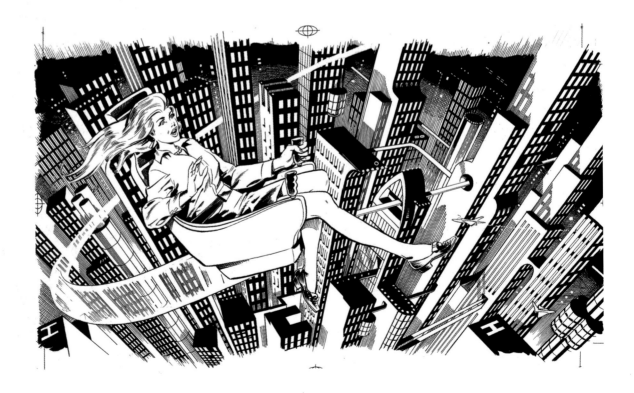

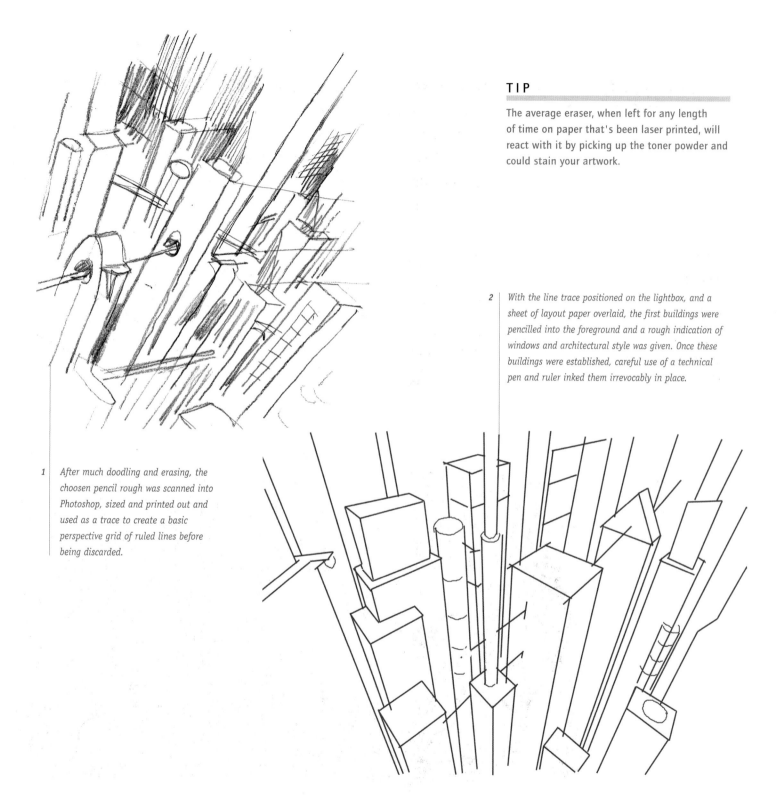

2 | With the line trace positioned on the lightbox, and a sheet of layout paper overlaid, the first buildings were pencilled into the foreground and a rough indication of windows and architectural style was given. Once these buildings were established, careful use of a technical pen and ruler inked them irrevocably in place.

1 | After much doodling and erasing, the choosen pencil rough was scanned into Photoshop, sized and printed out and used as a trace to create a basic perspective grid of ruled lines before being discarded.

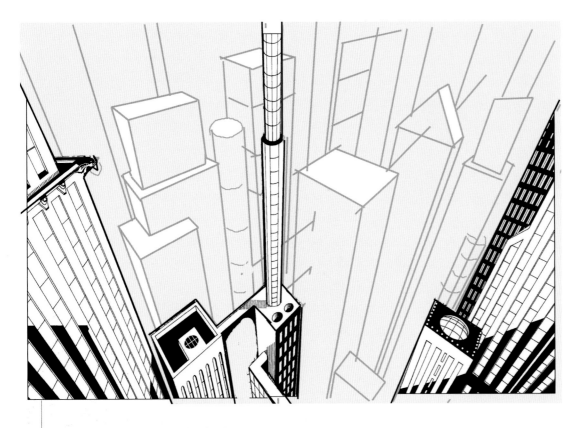

3 | All the other buildings were drawn in related
perspective to these first inks. Additional guide
lines were pencilled in by the simple expedient of
dividing existing pairs of perspective lines. This
was done using a time-saving 'tool' consisting of
three dots equally spaced and notched into the
edge of a piece of paper.

4 | The two outer dots are laid diagonally to match the top of
the two sides of the building and the centre dot position
marked. This repeated further down the building gives
another central mark, which, when the two are joined,
neatly and accurately bisects the building to give a
vanishing point guide. The same principle applies to the
other two vanishing points on the right and left. Because
there were so many divisions and sub-divisions required,
the finer ones were guessed at. On the original artwork the
roof tops were solid black to emphasise the light source
being at street level. On this colour hybrid they were
broken up slightly by adding detail. The windows on the
original were deliberately simplified and kept to white
windows/black walls. This gave a uniformity to the
background which became less distracting and helped
project the flying figure to the front. With the figure
absent a slightly more interesting background is possible.

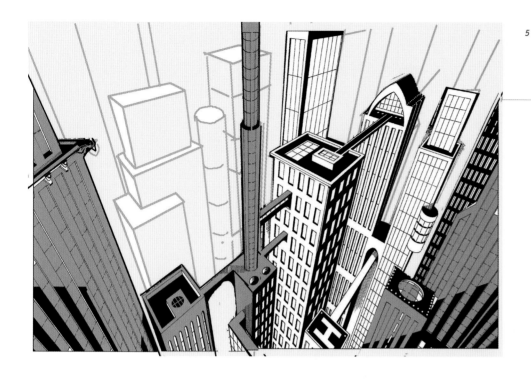

5 The second layer of buildings were then drawn behind the first, taking care not to let the effect of the smaller windows become too dark in comparison to the foreground art.

Only after the third layer was added could the far background be filled in with vertical and cross-hatch technical pen line. The addition of a solid black infinity gives the illusion of a dark, sprawling city. **6**

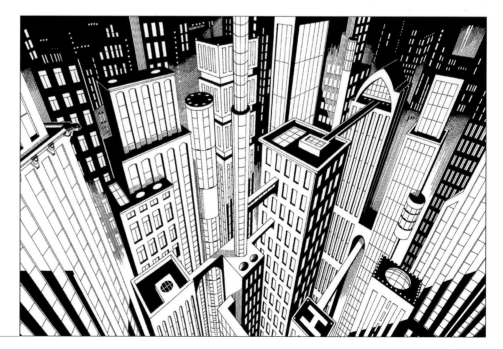

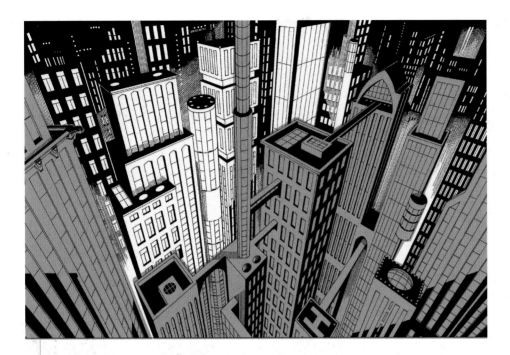

7 | *Colour was applied in Photoshop by duplicating the black-and-white art as a CMYK layer, then selecting a patch of white and 'selecting similar' so as to grab all the white areas of the top layer. These areas were cleared to make them transparent and attention was then given to the background layer. The 'select all' and 'clear' tools were used to erase the linework and the 'circular gradient' tool was selected with two colours, to apply as a basis for the final colour tweaks. Where to site the centre of the gradient tool is a matter of trial and error, and should be viewed through the top layer to guage the best effect. The two layers were then flattened and selected portions re-'paint potted' using the 'pipette' tool to lift grades of colour from other parts of the illustration.*

This particular cityscape does not show the streets but indicates their presence by suggesting them as a hidden light source. Without such ground-level distractions, an illustration like this becomes an ideal backdrop for a flying figure. | 8

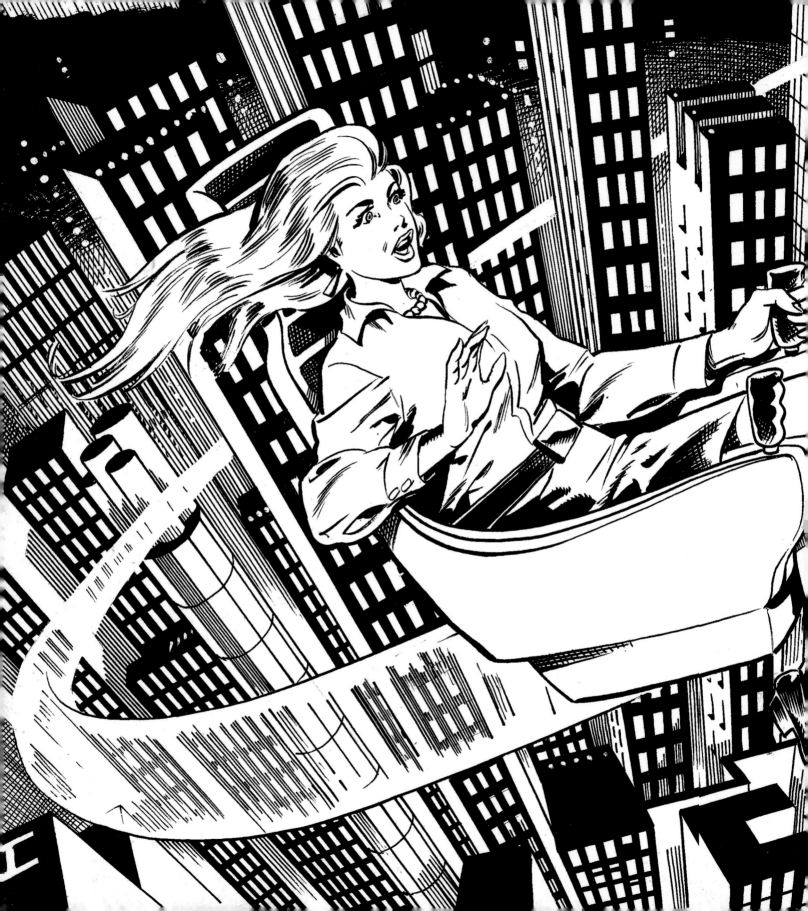

Glossary

Acetate
Clear plastic film used as overlays on artwork.

Airbrush
Pen-sized tool with reservoir for application of inks/paint by means of an air jet.

Alignment
Horizontal or vertical arrangement of text.

Application
Computer software for specific tasks, for example, Photoshop.

Back Up
Copying computer files to an external or alternative source.

Bit
Binary Digit. Smallest unit of information used by a computer.

Bitmap
On screen image made up of pixels.

Bleed
Part of an image that extends beyond the page trim marks.

Body Copy
The bulk of the text of a publication (sometimes called running text).

Brief
A written or verbal set of directions regarding a proposed illustration.

Browser
Computer program for internet interaction.

Camera Ready Artwork
Completed artwork measured and marked up ready for the printer's camera process.

Caricature
Pictorial representation of a person or person's character.

Cartoon
A full-sized drawing as a design for an illustration; a satirical or a politically amusing drawing.

CD ROM
Abbreviation of Compact Disk Read Only Memory. Plastic disc inscribed with information by laser beam.

Clip Art
Copyright-free images.

Complementary Colour
One of a pair of colours that oppose each other on the spectrum wheel.

Compass
A mechanical hinged bracket with a fixed point and free drawing tip for describing circles.

Composition
The aesthetic balance of design elements such as colour and shapes.

Copy
The text or pictorial matter to be set for printing.

Copyright
The legal right to prevent the copying of written work, images or designs.

CU
Abbreviation of 'close up'.

Display Type
Type designed for larger headings.

Document
Computer file containing text, designs or artwork.

Doodling
A relaxed and free-form method of drawing wherein the subconscious plays a part.

DPI
Dots per inch – the measurement of the resolution of an image.

DPS
Double-page spread. Left and right-hand pages designed as a single unit.

DTP
Desk Top Publishing – computer-generated design for print and or publication.

Dummy
Mock-up or prototype of a publication or piece of work.

Duotone
Half-tone illustration or photograph printed in two colours.

E-Mail
Electronic mail sent via the internet.

EPS
Encapsulated PostScript – computer format for transferring linear and tonal work into digital layout programs.

Flat Plan
Diagram showing proposed position and content of pages in a publication.

Folio
Page number printed on a page. Also, a single sheet of manuscript.

Font
A full set of uppercase and lowercase alphabet characters and their related punctuation marks, signs and symbols.

French Curves
A series of multi-curved templates to enable the drawing of compound curves.

Gag
Verbal or graphic rendition of a short joke.

GIF
Graphic Interchange Format – computer format for graphics with flat areas of colour.

Graphic Tablet
Electronic drawing pad used as a means to communicate graphically direct to a computer.

Gutter
Margins on either side of the spine on the pages of a publication and also the space between columns of text.

Half Title
The first page of a book, which has only the title of the book printed on it.

Half-tone
Refers to an image where tonal values are conveyed by a series of various sized dots.

Hard Copy
A paper printout of a digital document, file or illustration.

Hard Disk/Drive
Main storage mechanism of a computer.

Hardware
The actual physical parts of a computer and the peripheral devices such as printers and scanners.

Hue
A tint or tone of a colour

Icon
Small computer screen image that represents an application, tool or document.

Illo
Short for 'illustration'.

Imposition
Pre-print arrangement of pages to facilitate correct alignment after printing, folding and trimming.

Indentation
A setting short of the column measure.

Ink Jet
Method of printing whereby micro drops of ink are delivered to the paper by fine jets.

Invoice
An itemised demand for payment listing the invoice number, the date, contact, work done, purchase order number, addresses, etc.

JPEG
Abbreviation for Joint Photographing Experts Group – computer format for continuous tonal colour images.

Justified Text
Type set to align with both sides of a column sacrificing spacing for tidiness.

Keyline
Registration marks on overlays that enable the correct alignment.

Kerning
Adjusting the space between individual letters.

Lampoon
Satirise, mock, ridicule, parody, tease or make fun of (by cartooning).

Leading
The spacing between lines.

Light Box
Glass-topped box containing light source to enable tracing of paper-based designs.

Line Art
Drawing done in pure line without reference to tint or tone or extra colour.

Logo
A title or trademark-recognition device.

Lowercase
Small letters of an alphabet (not capitals).

Manikin
An articulated wooden figure proportionate to a human being.

Margin
The unprinted areas of a page.

Mask
A computer layer protecting a lower layer from certain digital treatments.

Matchstick Man
A human-like figure comprising single line limbs and a circular head.

Measure
Width of a line of type or column.

Menu
Computer commands or options.

Modem
Device enabling digital data to be transferred via the telephone line.

Mouse
Hand-held device for communicating with a computer.

Opaque
Not transparent to light.

Overlay
A protective sheet of acetate or paper carrying colour, keyline information or notes.

Overprint
One colour or image printed over another.

Proof
Pre-print hard copy of a proposed publication used for checking layout of design, text and colour.

Paste Up
Physically cutting and pasting various elements on a board to form a dummy. Computer term for duplicating and moving digital objects from one document to another.

PDF
Abbreviation of Portable Document Format – a cross-platform computer file format.

PC
Abbreviation of 'personal computer'.

Pixel
A single dot on a digital display.

Point
Smallest type measure (= $1/72$ of an inch)
12 points = 1 pica , 1 pica = $1/6$ inch.

Propelling pencil
Mechanical pencil containing a means
of propelling lead through its barrel to
its point.

Quark Express
Computer software for pagination
favoured by designers, writers, artists etc.

RAM
Random Access Memory.

Raster
Horizontal scan line on a computer
screen.

Recto
The right-hand page of a book.

Registration
Alignment of overlays etc., by means
of registration marks.

Resolution
Measure of sharp detail in a digital
image, DPI dots per inch.

Reverse Out
Printing to achieve the effect of light
colours out of dark backgrounds.

Sable Brush
Brush tipped with selected pure
sable hair which is of uniform and
slender taper.

Sans Serif
A typeface without serif (see serif below).

Scaling
Adjustment of text or artwork size
usually by computer.

Scalpel
A surgical knife that can be fitted with a
variety of extremely sharp cutting blades.

Scanner
A device for converting images into
digital information for transference
to a computer.

Serif
Small flourishes on the ends of the main
strokes on a typeface.

Software
Programs, applications or instructions
that enable a computer to carry out
specific tasks.

Spot Cartoon
A stand-alone cartoon drawing of
any size which may or may not have
related text.

Spot Colour
The application of a single extra colour
on a line drawing.

Speed Lines
Sometimes called whizz or zip-lines, these
are lines drawn behind an object
to indicate speed or direction.

Steel Nib
Metal pen nib usually split and
perforated to allow ink to be retained.

Strip
A series of sequential drawings running
on one level or bank.

Stylus
Pointed tool used in place of finger for
touching and rubbing fragile surfaces.

Technical Pen
Designed to draw lines of a fixed and
predetermined width. Referred to as wire-
lines, they have a built-in ink cartridge.

Thumbnail
Miniature compact drawing done as a
design for a larger and more detailed
illustration.

TIFF
Tagged Image File Format – computer
format for transmission of files.

Tint
Shade, tone or hue of a given colour.

Tracking
Adjustment to spacing between all letters
in a text.

Typeface
The distinctive style of a type family
or letter.

Upper Case
The capital or large letters of an
alphabet.

Verso
The left-hand page of a book.

Vignette
Drawing without enclosure or border.

Wire-line
A line with little variety of width as
drawn with a hard nib or technical pen.

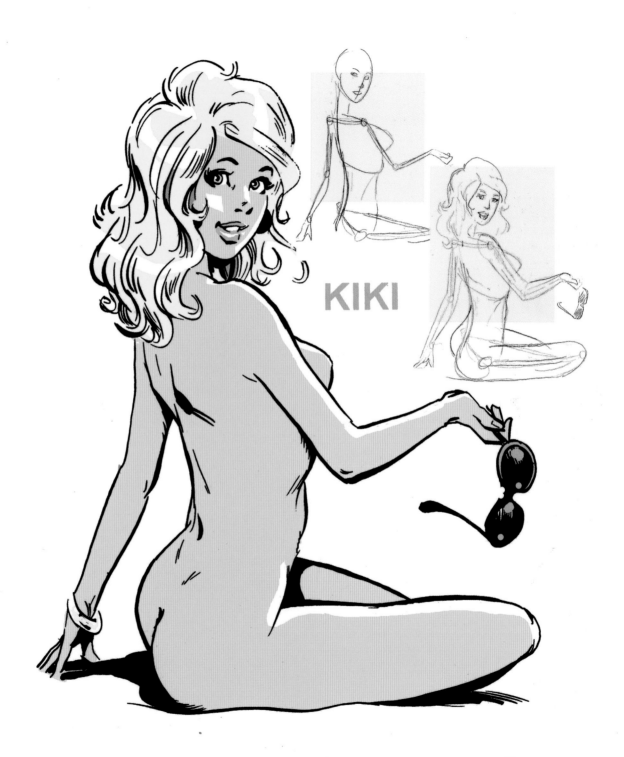

KIKI

Index

Picture credits and permission

All illustrations by John Richardson apart from the following.
page 8 B. Franklin, *Pennsylvania Gazette*
pages 9, 10 (top left) courtesy of Mail Newspapers plc/SOLO Syndication
pages 10 (right), 11 courtesy of Mirror Group Newspapers
page 59 courtesy of Ian Watson

The author would like to thank the following for permission to
reproduce images:
Top Hat publishing: *Help, I'm a Dinosaur* and *Escape from Colditch*;
Macmillan: Dame Edna Everidge's *My Gorgeous Life*
Mr Ian Watson (featured in *The Sun)* for the use of 'Amanda' cartoon
from his collection
DC Thomson: Pussy Muldoon cartoon strip
Rare Ltd: Lunar Jetman
Financial Adviser: Regulation street cartoon strip

Acknowledgements

This book is dedicated to all those tutors past and present at Green Lane
College of Art who daily face the challenge of developing the potential in
their students, and to those student colleagues of mine who daily tried their
level best to retard that development and in so doing nudged me into the
world of cartooning. May tutors everywhere keep up their good work and
may every student be as fortunate in their friends and colleagues as I have
been. Might I also pay tribute to the editor, Nina Sharman, and designer,
Kate Ward, John Conway and others at Essential for their guidance and
supreme patience, and to Pearl for being more than a good wife and
allowing me to become a recluse to get the job done. Last, but very far from
least, goes my acknowledgement of the part played by the members of the
Priory Club, everyone of them, whose characteristics and eccentricities have
been enough to keep me in ammunition for several years. Thanks to Val and
Colin, Tracey and Dave, Thomas, Orla, and baby Sophie for the use of their
likenesses, their time and their patience. Cartooning, like every other
occupation, has it's ups and downs, it's feasts and famines and its financial
fluctuations, but I maintain that drawing cartoons is not only a proper job,
but also ranks up there as being one of the best professions in the world.